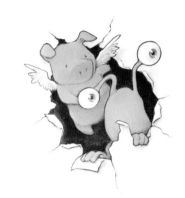

TEMPORARY
PRESERVES

All photographs © 2015 David Zinn unless otherwise indicated

Production and editing assistance by Carolyn Bishop

Printed in the United States of America
by Thomson-Shore, Inc.
7300 West Joy Rd.
Dexter, MI 48130

First Printing, 2015

ISBN 978-0-9912206-1-8

Lost & Unfounded, LLC
Ann Arbor, Michigan
zinnart.com

TEMPORARY PRESERVES

CHALK ART BY DAVID ZINN

Lost and Unfounded, LLC ◇ Ann Arbor, Michigan

DEDICATION

Dedicated to my parents for
encouraging me to draw on
placemats in restaurants, notepads
in waiting rooms, and the
underside of the world at large.

And to my brother for making sure
I never had to draw alone.

TABLE OF CONTENTS

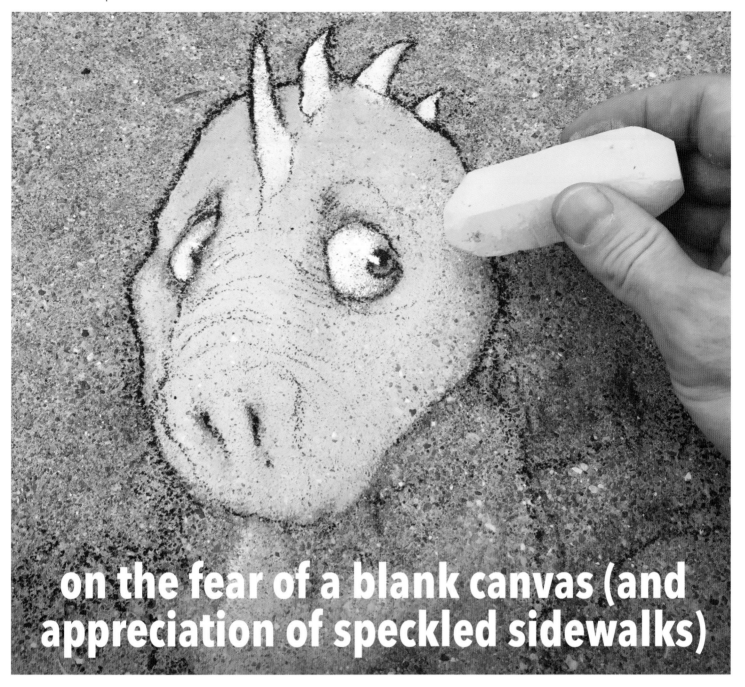

on the fear of a blank canvas (and appreciation of speckled sidewalks)

I have a terrible fear of blank canvases. I don't think this is unusual; in fact, I think this fear explains why so many people claim that they can't draw and yet doodle happily in the margins of things. It's why drawing a mustache on a person who doesn't have one is more satisfying than drawing a portrait of someone who does. I think most of us, artists and non-artists alike, regard a perfectly blank piece of paper as more of a curse than an opportunity. There are too many options, and we fear that we might regret our choice and wish the paper could be made blank again.

As children, my brother and I solved this problem through mutual destruction of each others' blank papers: I would scribble a meaningless shape on his, and he would scrawl a nonsensical blob on mine. The challenge then was to make something – anything – out of what had otherwise just become a ruined piece of paper. Luckily, nothing feeds the imagination like a random scribble that looks slightly like a robot iguana.

More recently, when looking for an excuse to be outdoors while technically "working," I discovered that the sidewalk is a lot like a pre-scribbed paper. Everywhere I look, there are specks, cracks, and smudges that my inner child wants to turn into things. Often it's something I've never drawn before; sometimes I'm not even sure what it is when I'm finished drawing it. Luckily, there's no need to worry about how "good" the "art" is, because it's just chalk dust underfoot and the rain will soon wash it away. If I'm lucky, someone will see it first . . . or maybe even draw a mustache on it.

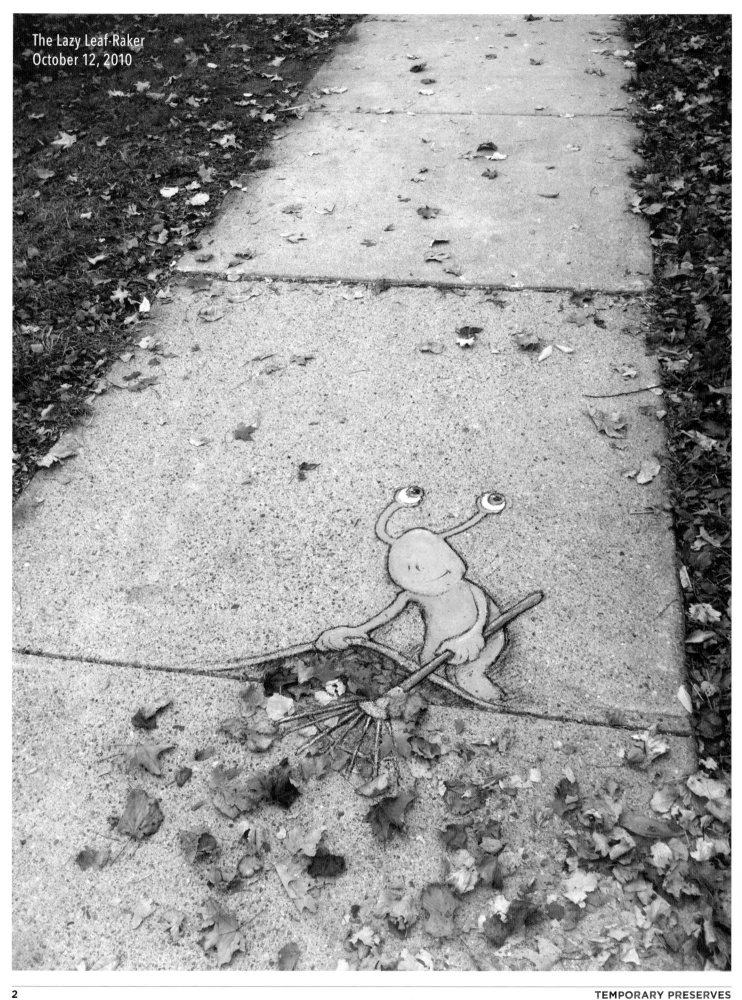

The Lazy Leaf-Raker
October 12, 2010

The photo on the left is arguably my most well-known piece of street art. The original was drawn across the street from my house five years ago and erased by the rain soon after, and yet the image continues to wander the alleyways of the Internet (and, if e-mails from strangers can be believed, the streets of Sao Paulo and Shanghai), re-emerging every few months as an example of the crazy stuff people do with chalk and too much time on their hands.

This persistence is gratifying but also frustrating, because it exposes the paradox of sharing chalk art on-line: the drawing only lasts a few days, but an uploaded photo is as everlasting as a childhood embarrassment fondly remembered by your mother. Wish you could forget that you used to draw that silly alien creature with no feet and way too much torso? Too bad.

On the plus side, I have used this picture as a prime example of the benefits of using the world as a canvas: of all the visual elements in this photo, the only ones I had to draw were the creature and the rake. If it had been a conventional illustration, sketching all those individual leaves would have taken forever.

The drawing below has two titles. It was originally created at the Ann Arbor Hands-On Museum as decoration for their "Creature Feature Night," an event where exotic animals were brought in for children to see (and vice versa). Like many of the drawings in this book, it started without a plan; I drew a snake because I had just seen one, and the mice were added later to explain why he looked so confused. It was uploaded to social media under the title "Imitation is the Sincerest form of Flabbergastery" because 1) I couldn't explain what was really happening in the picture, and 2) I wanted an excuse to use the word "flabbergastery."

Half a year later, this drawing suddenly re-appeared on Twitter with far more popularity than it had originally received, and when I went to see what was going on, I found that someone had relabeled the photo with a better title: "Unity is Strength."

This is my favorite magic trick of art. You don't have to know why you're doing what you're doing in order for the result to have an effect. In fact, the less you try to put a message into your art, the more you leave space for someone else to find a meaning of their own. It's like having the opposite of psychic powers.

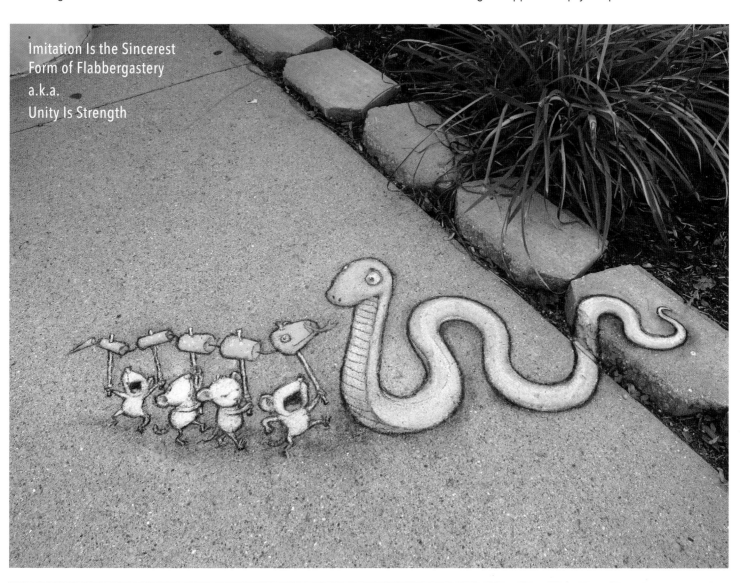

Imitation Is the Sincerest
Form of Flabbergastery
a.k.a.
Unity Is Strength

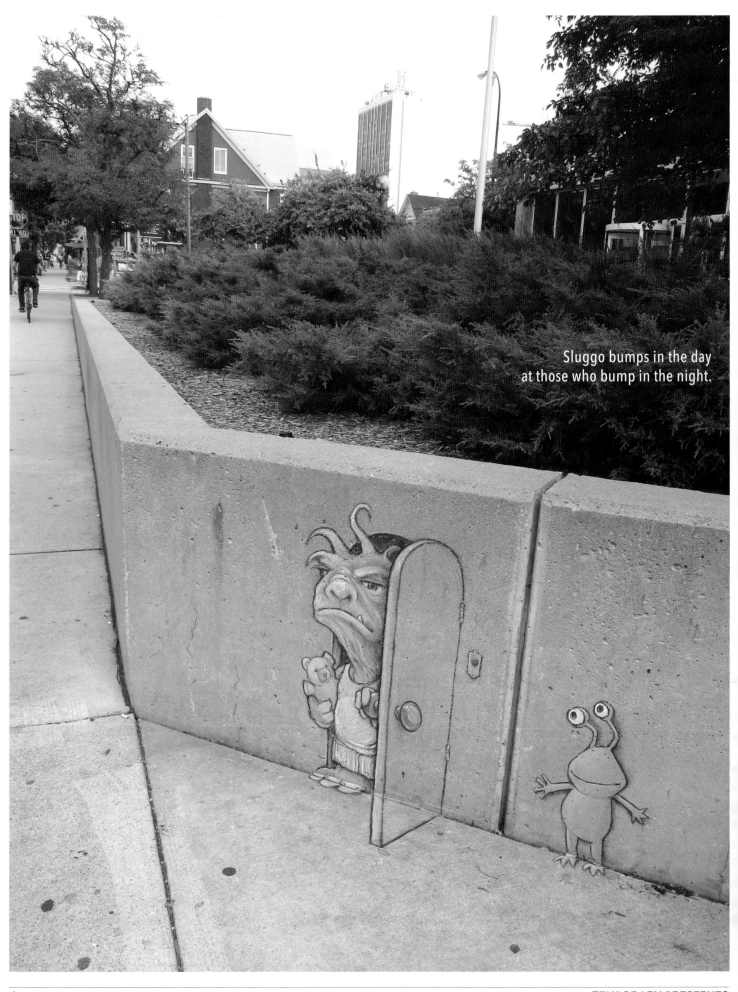

Sluggo bumps in the day
at those who bump in the night.

TEMPORARY PRESERVES

the improvised origins of sluggo

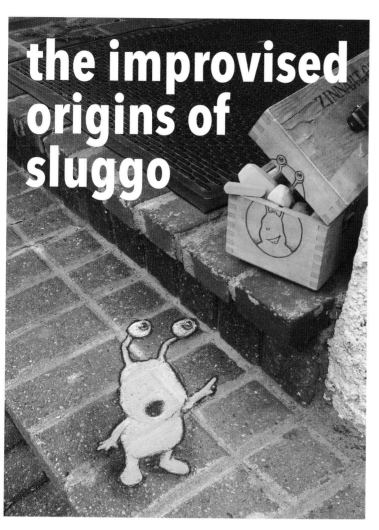

A few days later I was out on the sidewalk next to my house, happily connecting the dots on the concrete into what seemed to be a drawing of a happy kid dancing a jitterbug. Because of a peculiar arrangement of specks in that spot on the ground, his head was very tall, like an eggplant. When the time came to draw a face on this strangely aubergine *caput*, I couldn't find anywhere to put the eyes that didn't look awkward and sad. This was the first time I had ever struggled to finish a drawing on the sidewalk, and it was very upsetting. In a fit of annoyance, I drew his eyes well above his head, almost as if I was taking revenge on this horrible child who had ruined my winning streak of stress-free creativity on the sidewalk. At that moment, the sad, awkward child became a happy, awkward monster, and we've been friends ever since.

Mind you, we are friends on his terms, and he only shows up when he feels like it; I try not to promise to draw Sluggo for anyone, because he does not appear willingly on command.

I now think that Sluggo may have looked so unhappy in his first appearance because he was being forced to share the spotlight with a boy and his wagon. Sluggo is, in his heart and soul, a superstar.

Sluggo first appeared as cargo in a little red wagon pulled by a red-headed boy. Both boy and wagon had been drawn with chalk by the light of a streetlamp at the corner of Liberty and Fifth Street in Ann Arbor, because that was the only place where the sidewalk was sufficiently illuminated at one-o-clock in the morning.

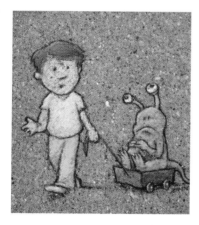

A drawing of a boy pulling an empty wagon is strangely unsatisfying to look at. In the years since, I have asked several people to visualize a child pulling a wagon, just to find out what they think the cargo should be. (Answers have included a dog, a large stone, and a tree.) In this case, possibly because the boy seemed to be looking back over his shoulder and talking to someone, I added a disgruntled green monster in the back of the wagon, arms folded and eyes wobbling above his head on stalks. He looked impatient and annoyed, as if he had launched an invasion from outer space only to end up as somebody's pet.

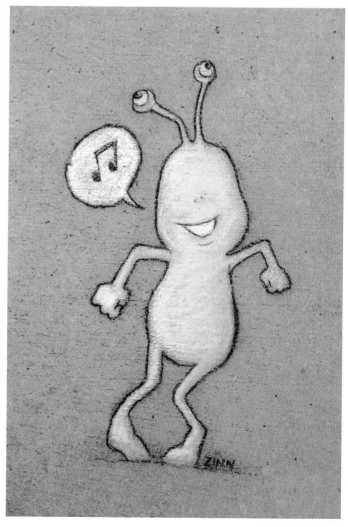

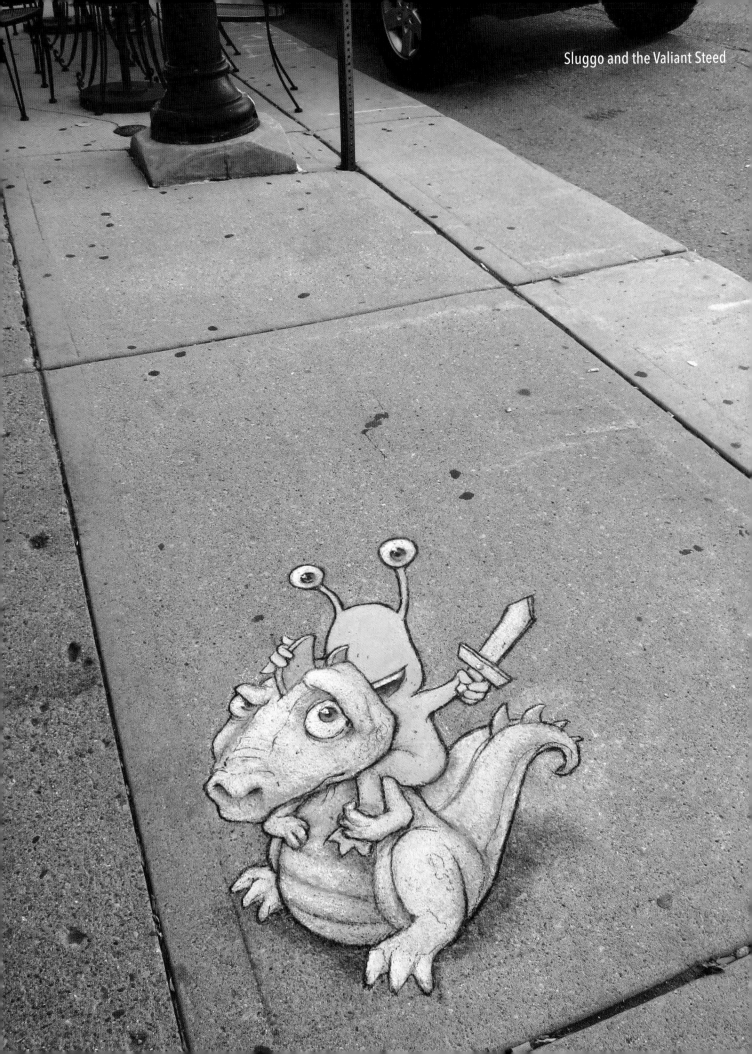

Sluggo and the Valiant Steed

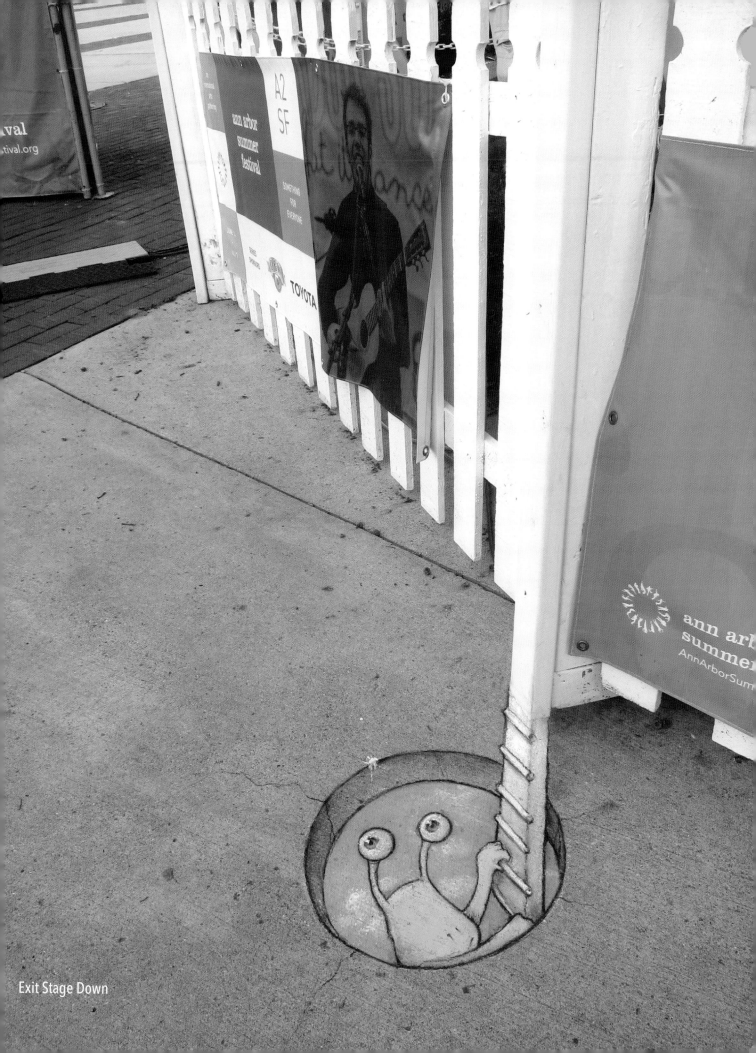

Exit Stage Down

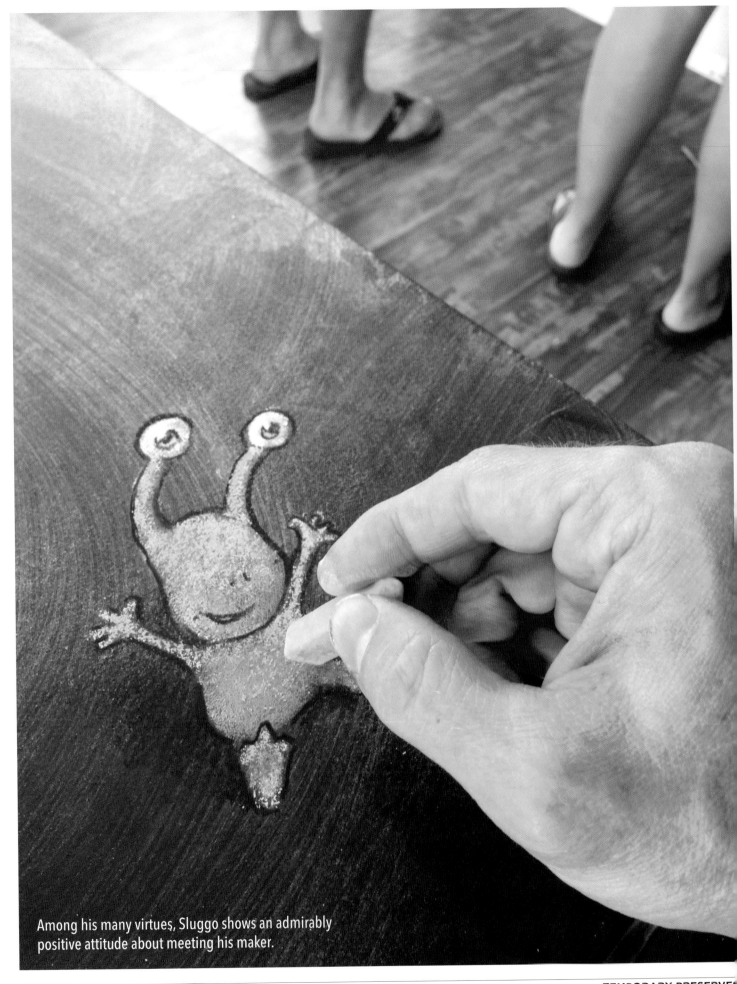

Among his many virtues, Sluggo shows an admirably positive attitude about meeting his maker.

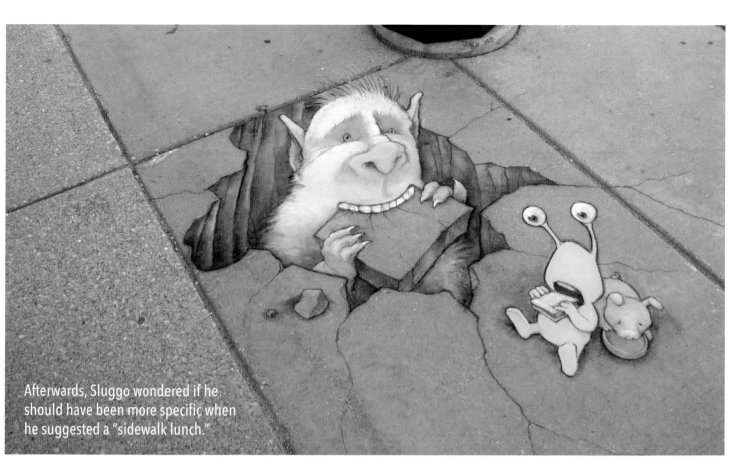

Afterwards, Sluggo wondered if he should have been more specific when he suggested a "sidewalk lunch."

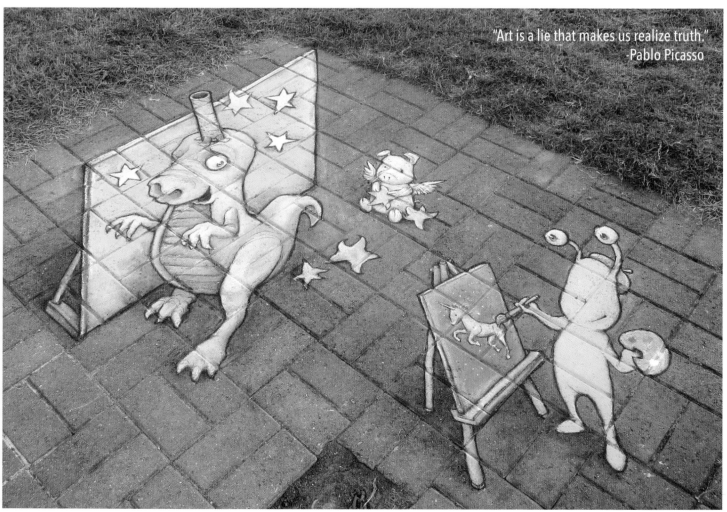

"Art is a lie that makes us realize truth."
-Pablo Picasso

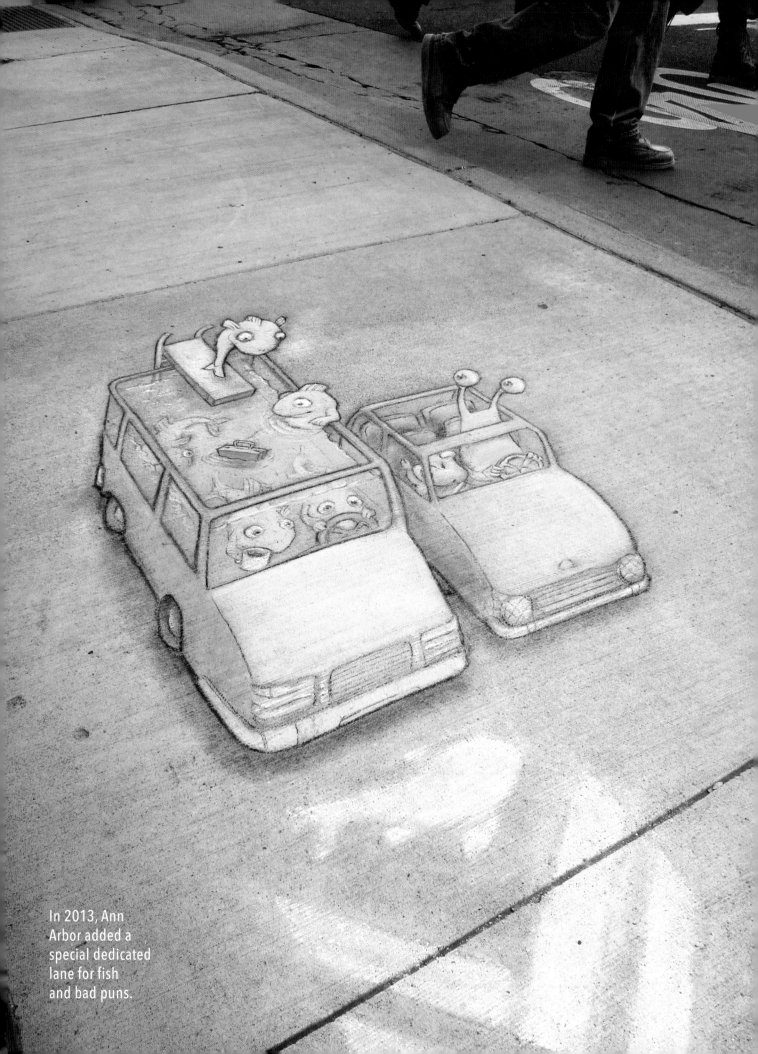

In 2013, Ann Arbor added a special dedicated lane for fish and bad puns.

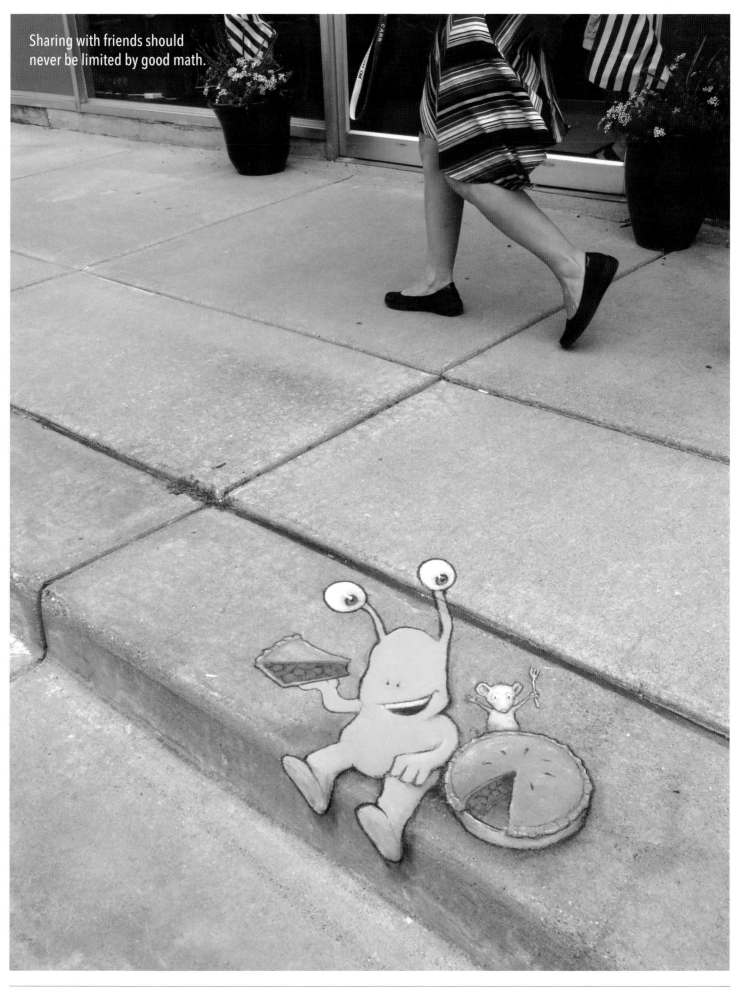

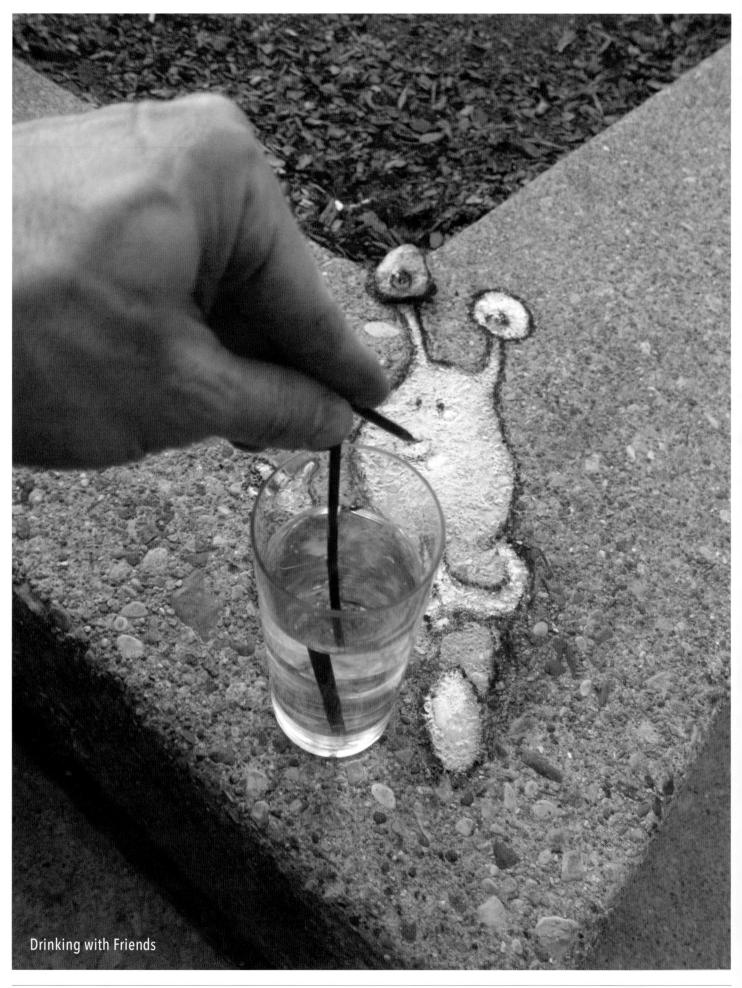

Drinking with Friends

TEMPORARY PRESERVES

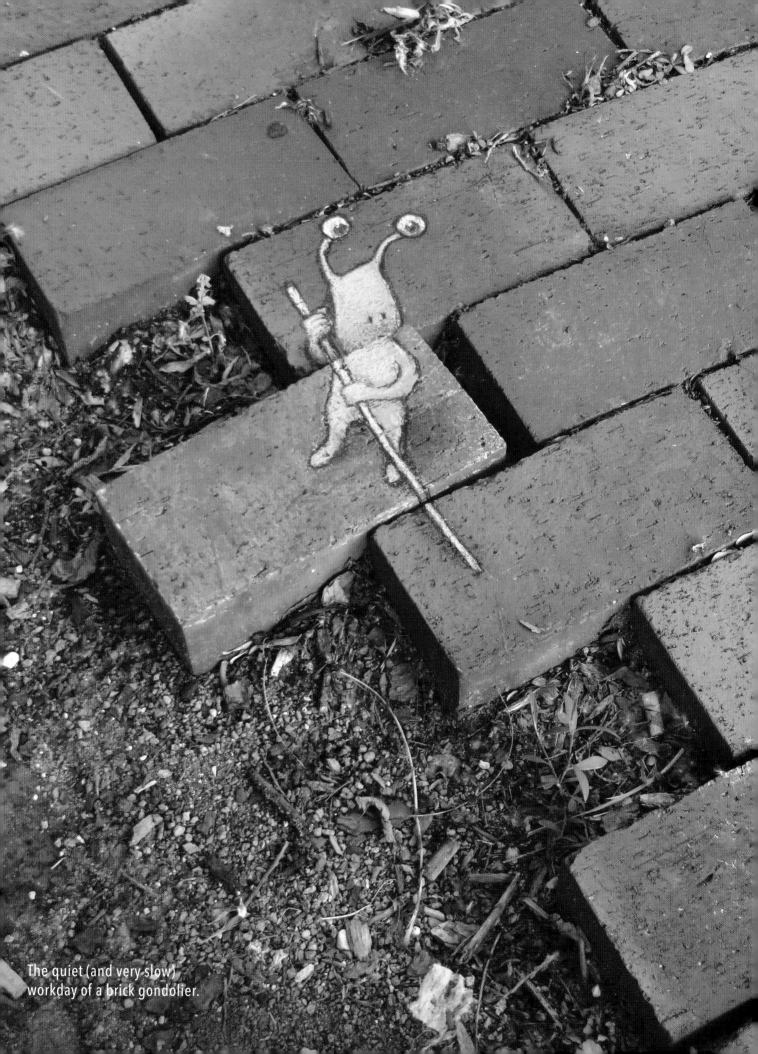

The quiet (and very slow)
workday of a brick gondolier.

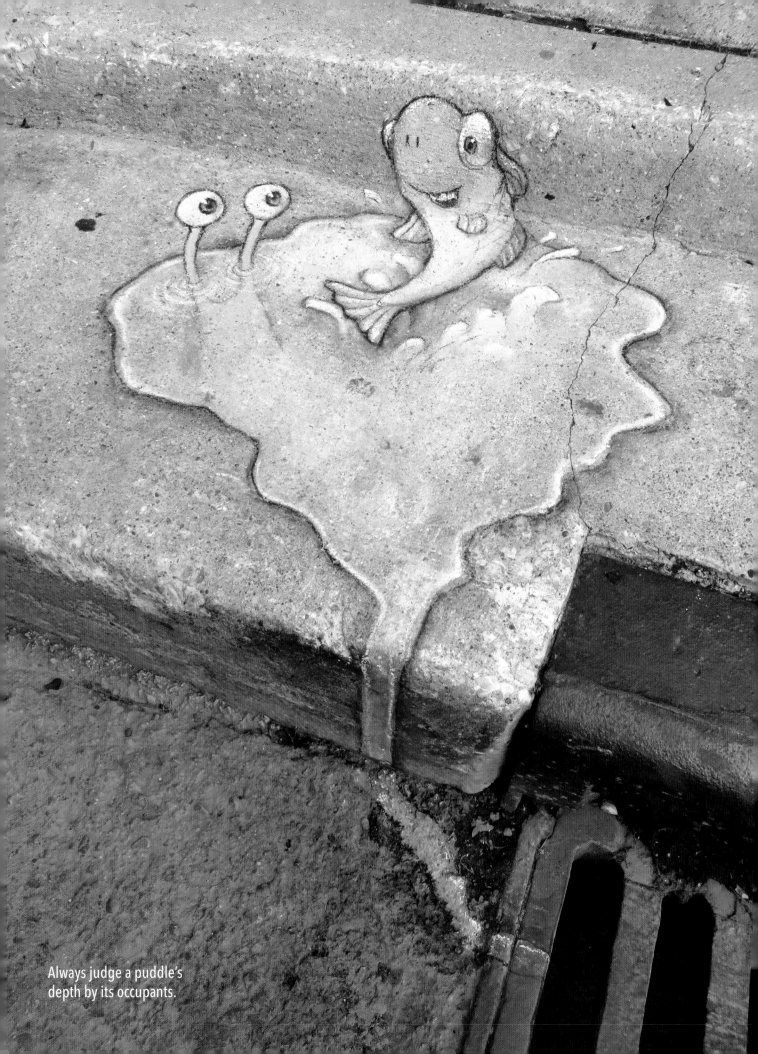

Always judge a puddle's depth by its occupants.

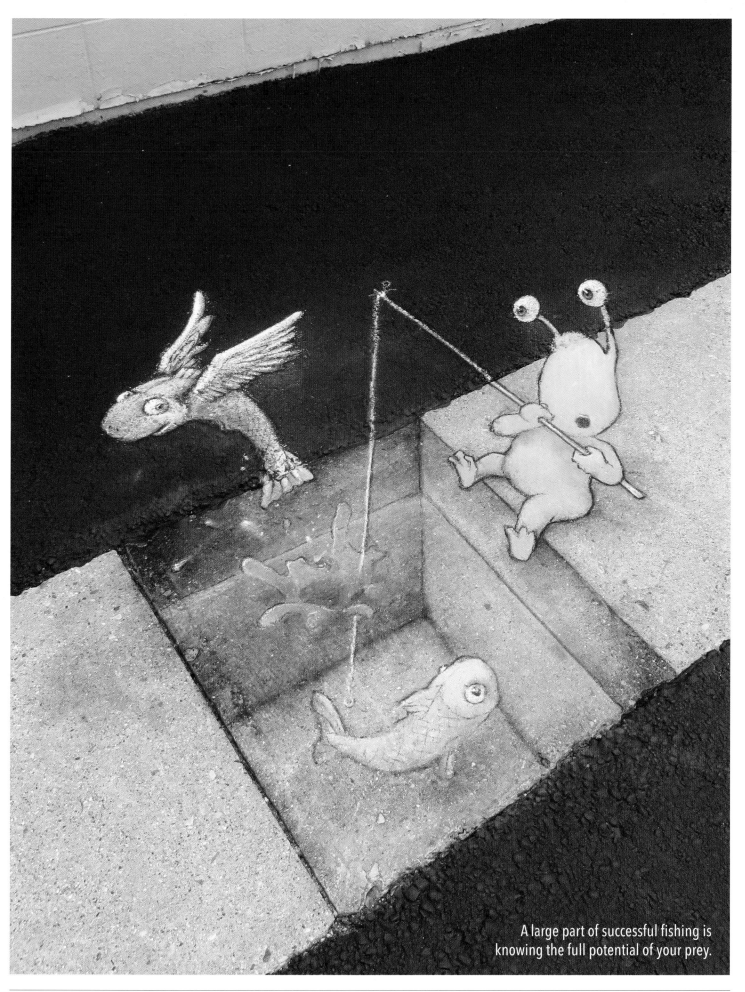

A large part of successful fishing is knowing the full potential of your prey.

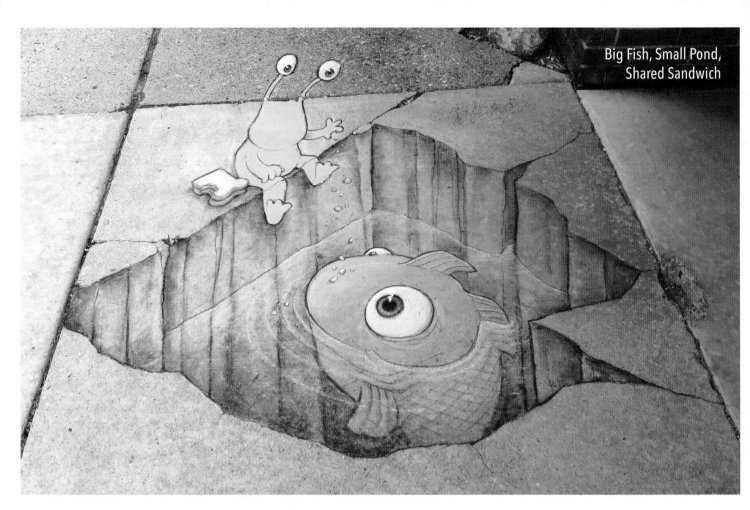

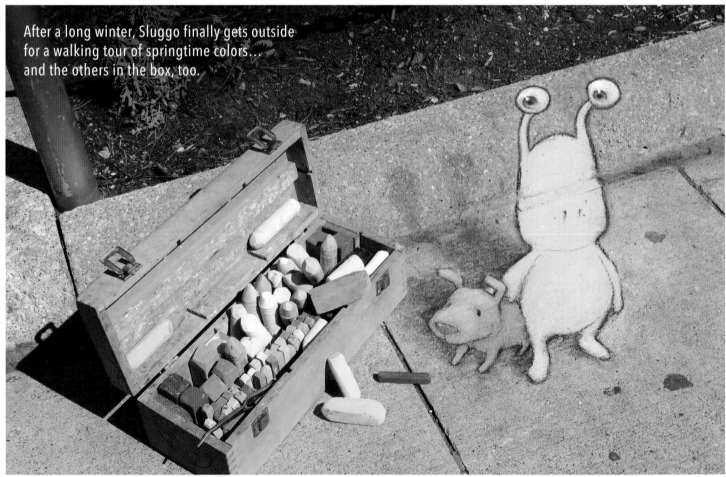

After a long winter, Sluggo finally gets outside
for a walking tour of springtime colors…
and the others in the box, too.

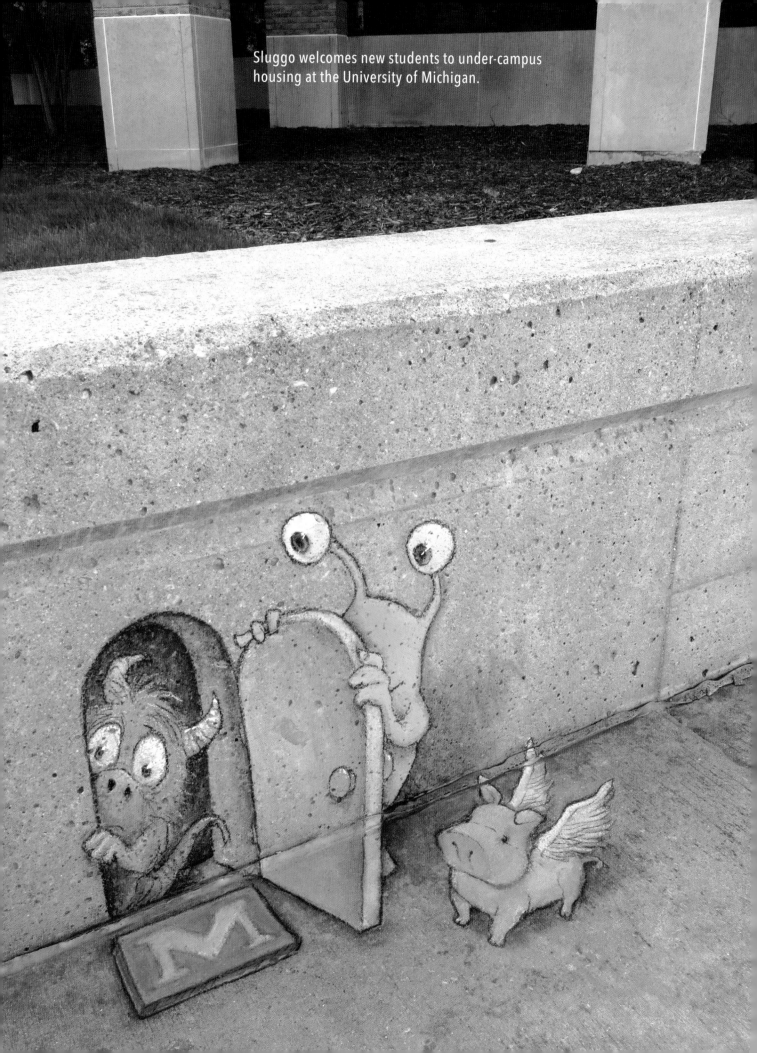

Sluggo welcomes new students to under-campus housing at the University of Michigan.

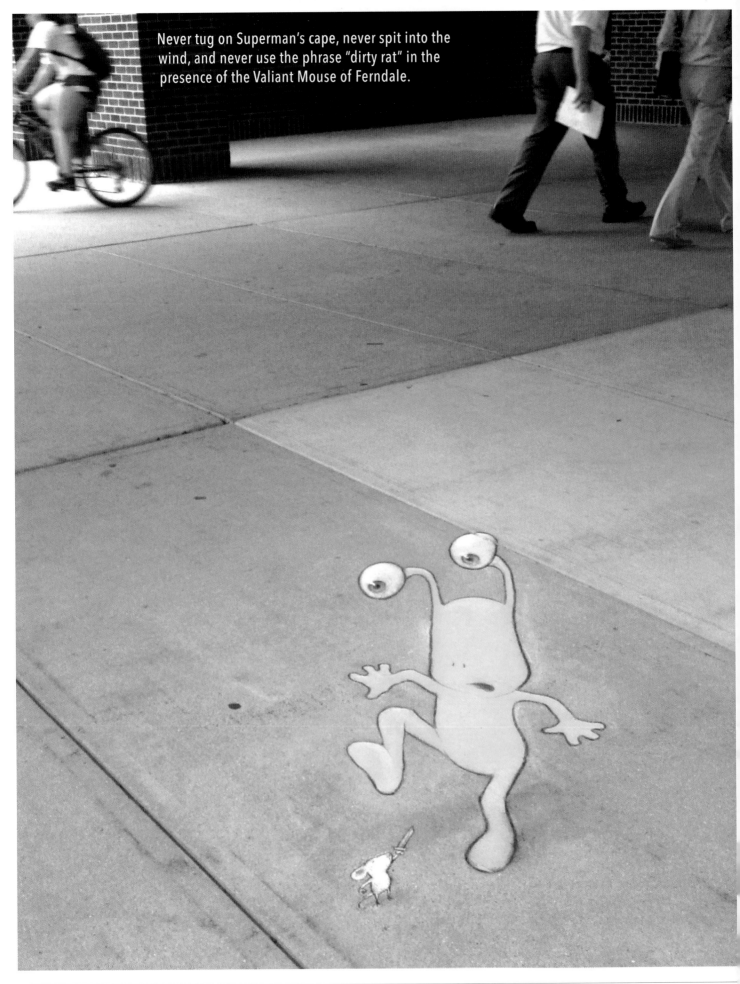

Never tug on Superman's cape, never spit into the wind, and never use the phrase "dirty rat" in the presence of the Valiant Mouse of Ferndale.

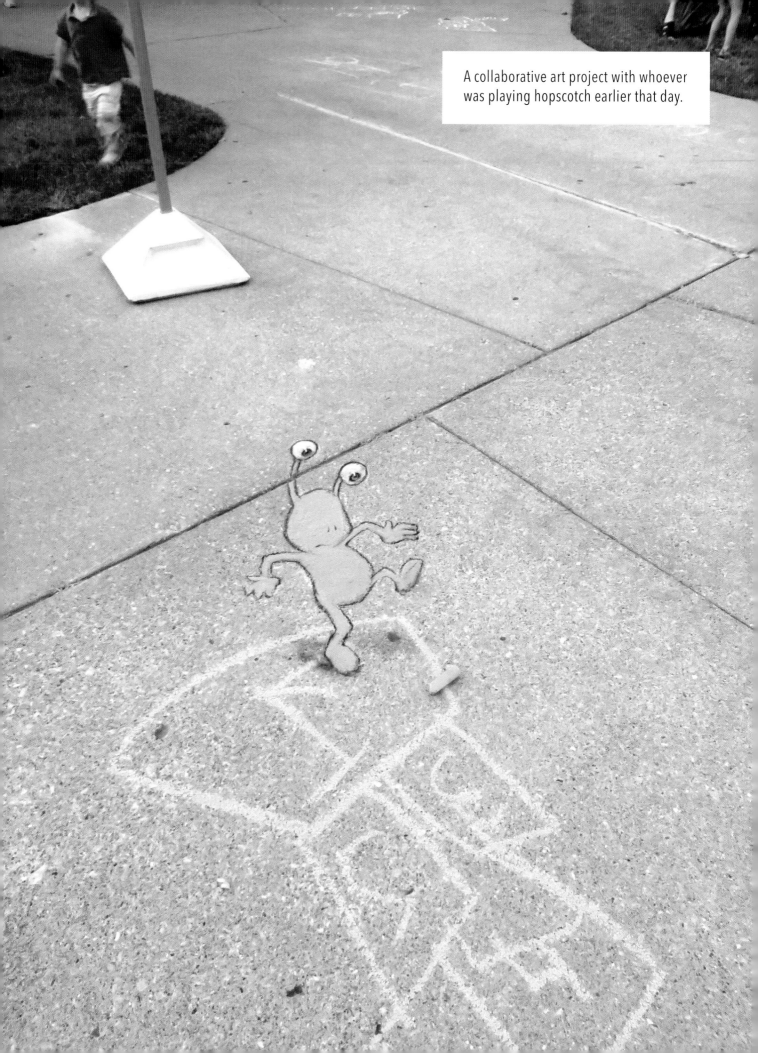

A collaborative art project with whoever was playing hopscotch earlier that day.

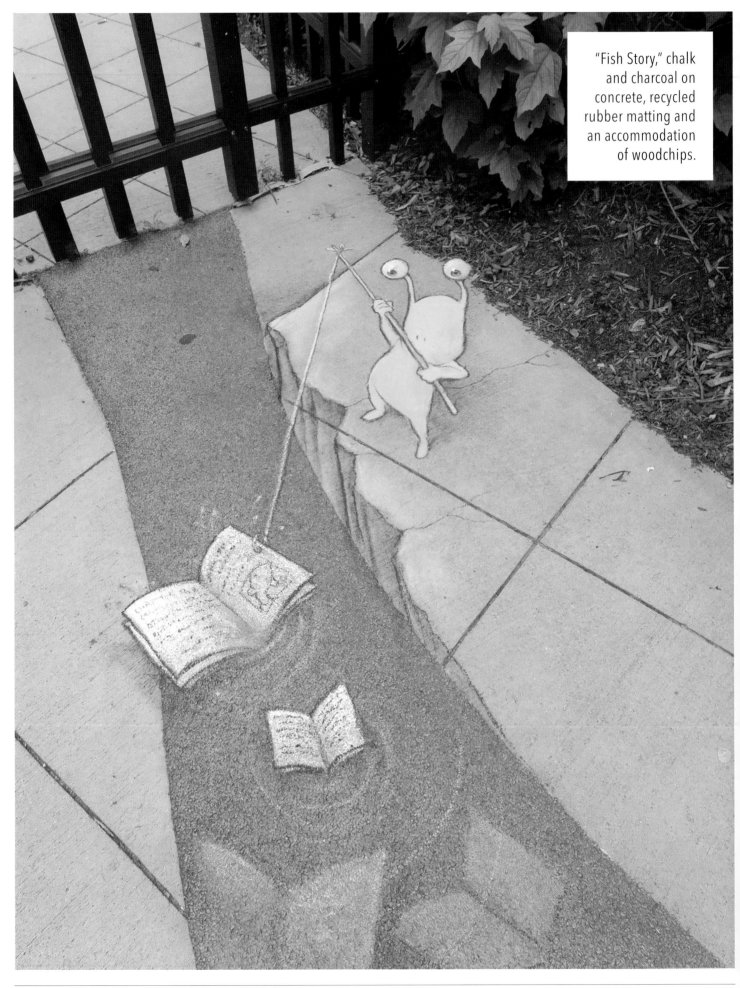

"Fish Story," chalk and charcoal on concrete, recycled rubber matting and an accommodation of woodchips.

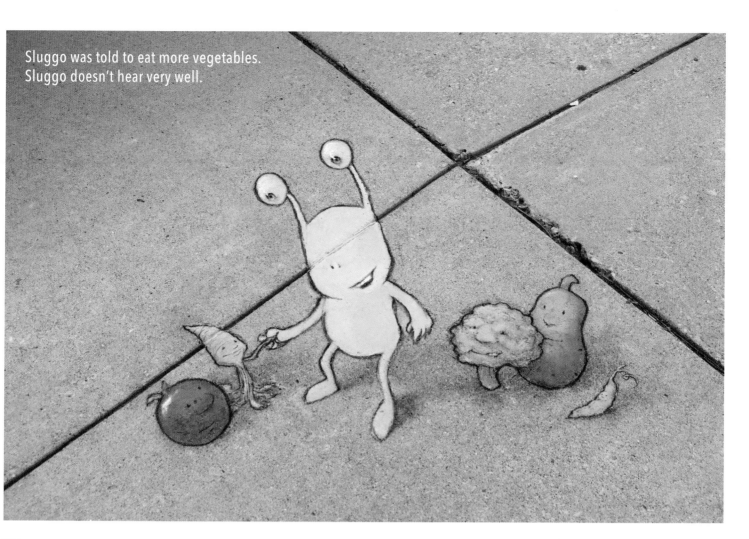

Sluggo was told to eat more vegetables.
Sluggo doesn't hear very well.

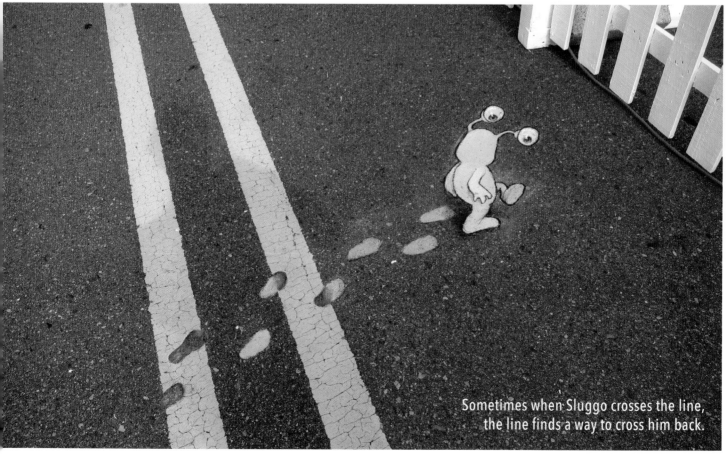

Sometimes when Sluggo crosses the line,
the line finds a way to cross him back.

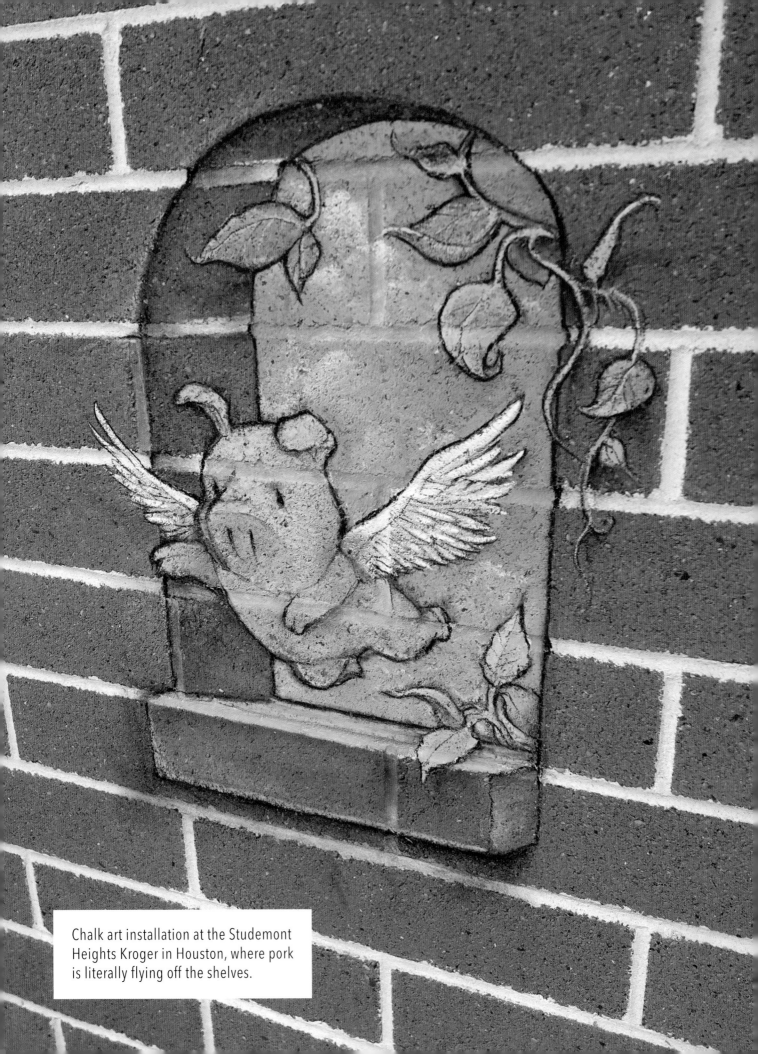

Chalk art installation at the Studemont Heights Kroger in Houston, where pork is literally flying off the shelves.

the significance of porcine aviation

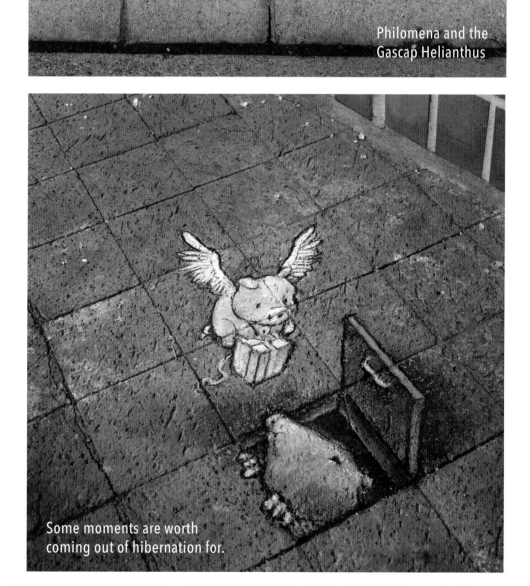

Philomena and the Gascap Helianthus

I drew my first flying pig at the request of a small child. Before that, I was just drawing wings on all kinds of animals at random, and didn't see the significance of pigs in particular. (I'm not convinced the child did, either; she may have just wanted to see me draw something pinkish.)

Since then, I have noticed that flying pigs have a strikingly positive effect on people. I think it's because the phrase "That will happen when pigs fly" is so inherently and needlessly discouraging. No one ever uses those words to be supportive or optimistic, even though the meaning would be equally applicable (e.g. "Don't worry, you'll fail that test when pigs fly!"). As a result, any sighting of a flying pig stands as a reminder that the Reputedly Impossible may be only Highly Unlikely. And unlikely things are well worth looking for.

Some moments are worth coming out of hibernation for.

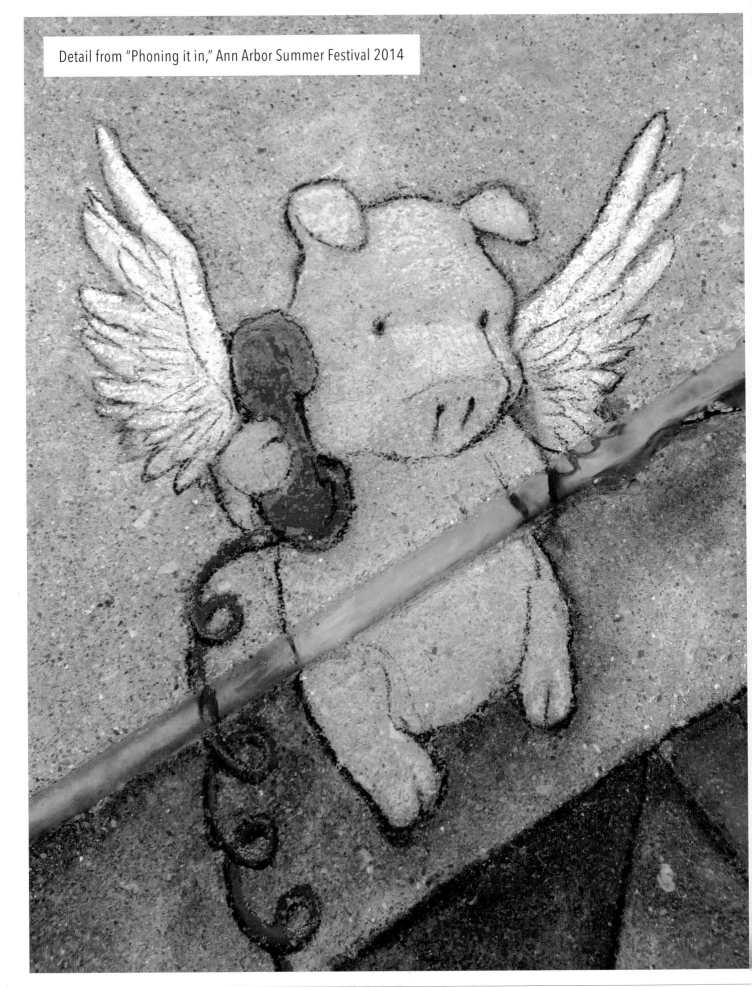

Detail from "Phoning it in," Ann Arbor Summer Festival 2014

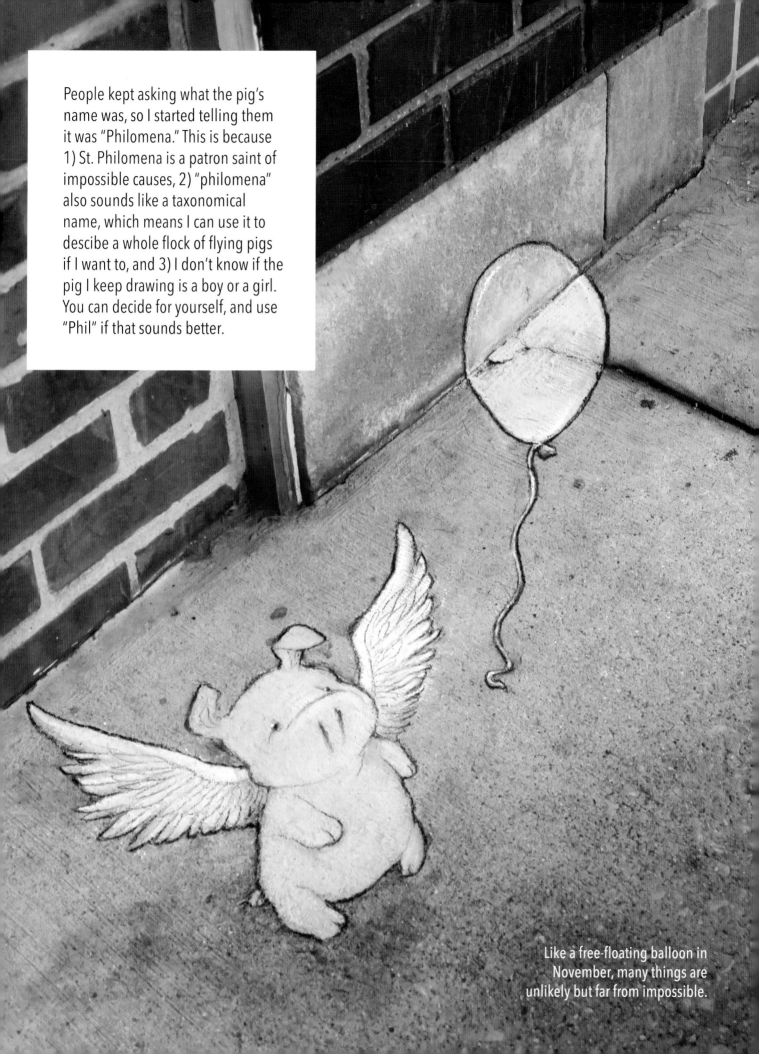

People kept asking what the pig's name was, so I started telling them it was "Philomena." This is because 1) St. Philomena is a patron saint of impossible causes, 2) "philomena" also sounds like a taxonomical name, which means I can use it to descibe a whole flock of flying pigs if I want to, and 3) I don't know if the pig I keep drawing is a boy or a girl. You can decide for yourself, and use "Phil" if that sounds better.

Like a free-floating balloon in November, many things are unlikely but far from impossible.

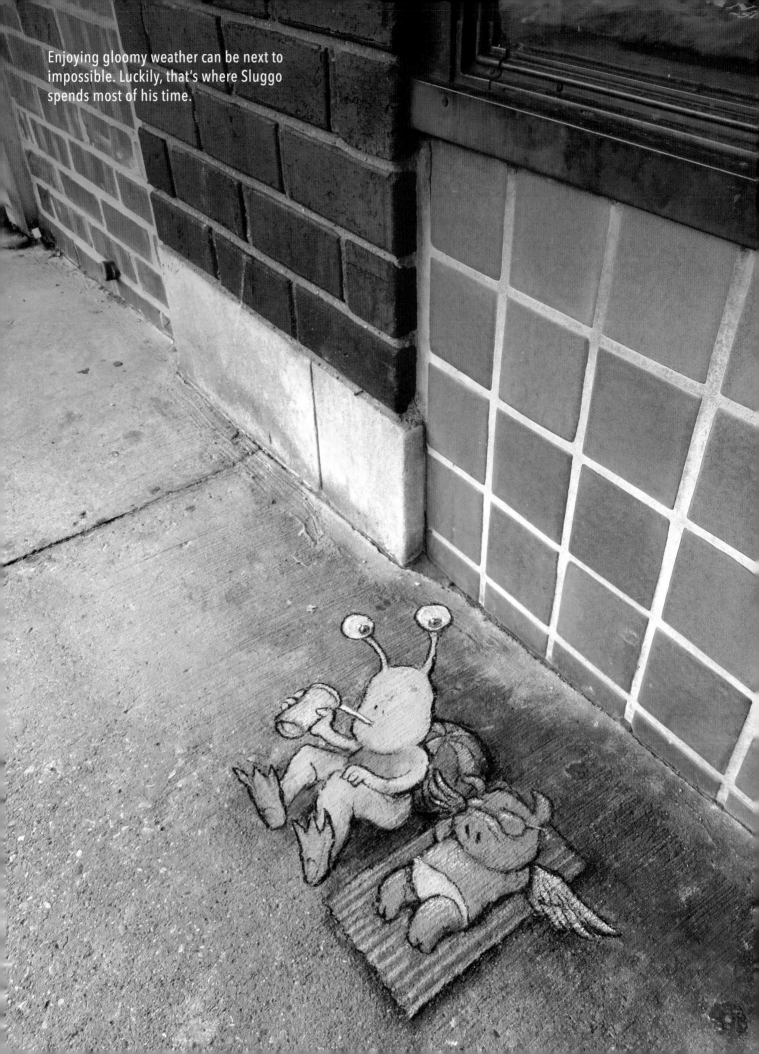

Enjoying gloomy weather can be next to impossible. Luckily, that's where Sluggo spends most of his time.

an improbable friendship

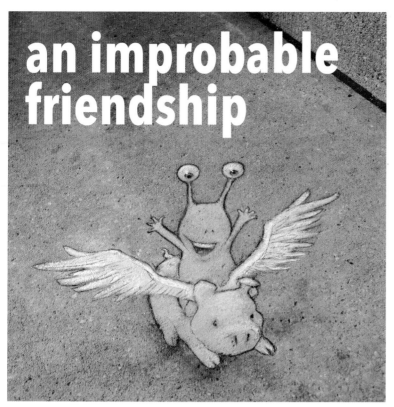

I once drew a picture of Sluggo trying to scare his flying pig friend by pretending to be a rampaging dragon. The "joke" was supposed to show the pig cowering in fear, but in response to a real dragon towering just over the shoulder of an oblivious Sluggo.

I drew ten different expressions of fear, terror, anxiety, excitement, and panic on that pig's face, but none of them looked suitable. After many erasures, I was forced to settle for a stony-faced pig pointing calmly towards the danger instead. In the end, even the dragon looked comparatively insecure. (See back cover flap.)

Since then, I have learned that there is a yin and yang of emotion to some friendships, and certainly to this one. Sluggo faces every situation with goggle-eyed zeal of one stripe or another, while Philomena looks on with the placid composure of someone who knows exactly what's going on and is patiently waiting for the rest of the world to catch up. I guess that's a fringe benefit of being an agent of the improbable.

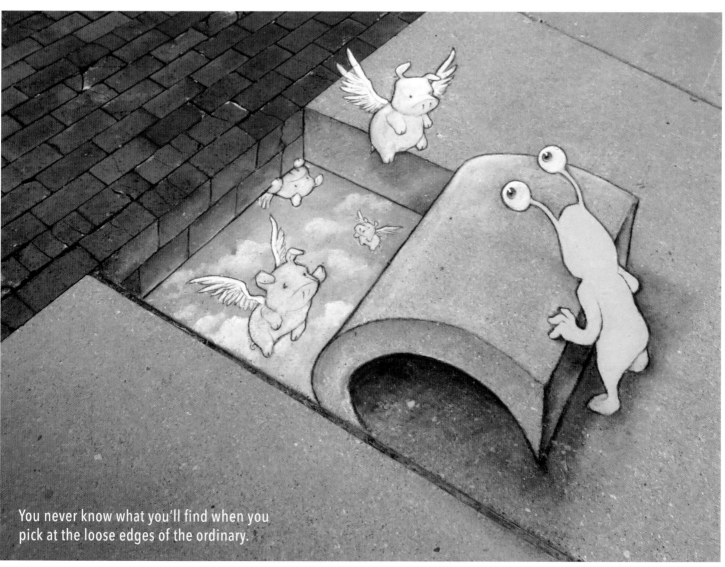

You never know what you'll find when you pick at the loose edges of the ordinary.

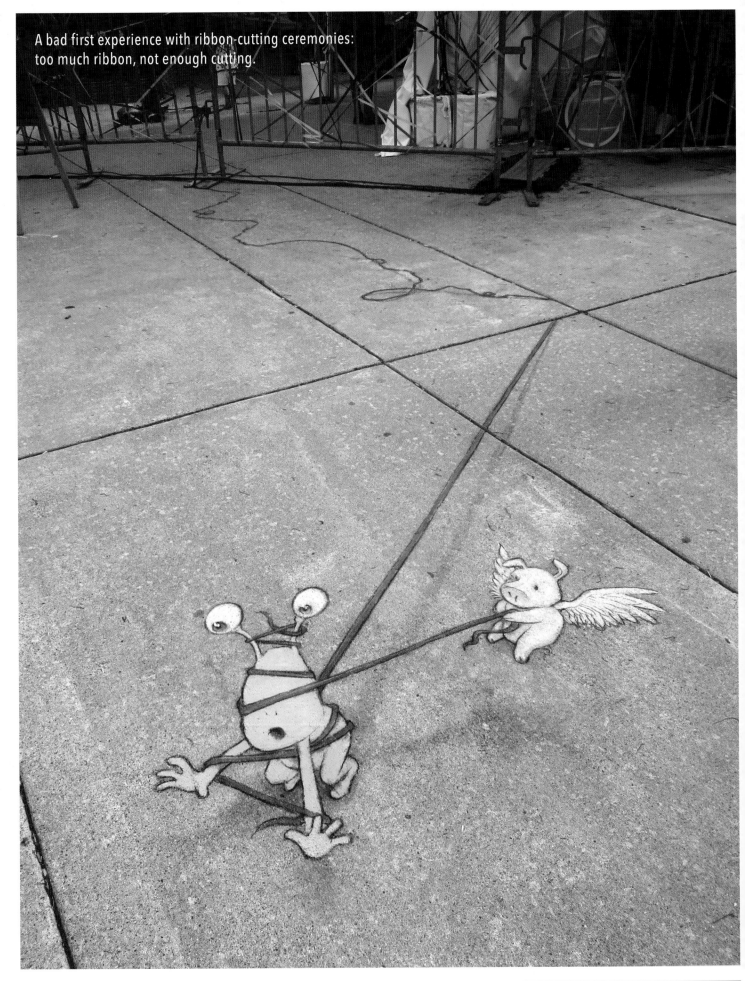

A bad first experience with ribbon-cutting ceremonies:
too much ribbon, not enough cutting.

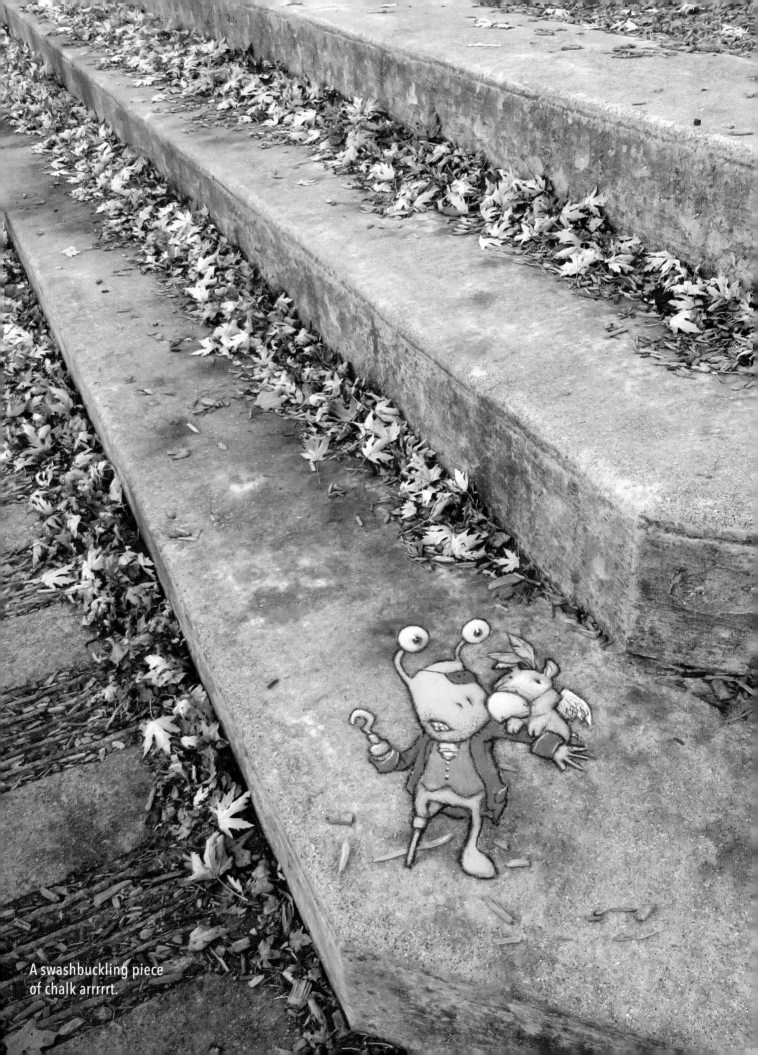

A swashbuckling piece
of chalk arrrrrt.

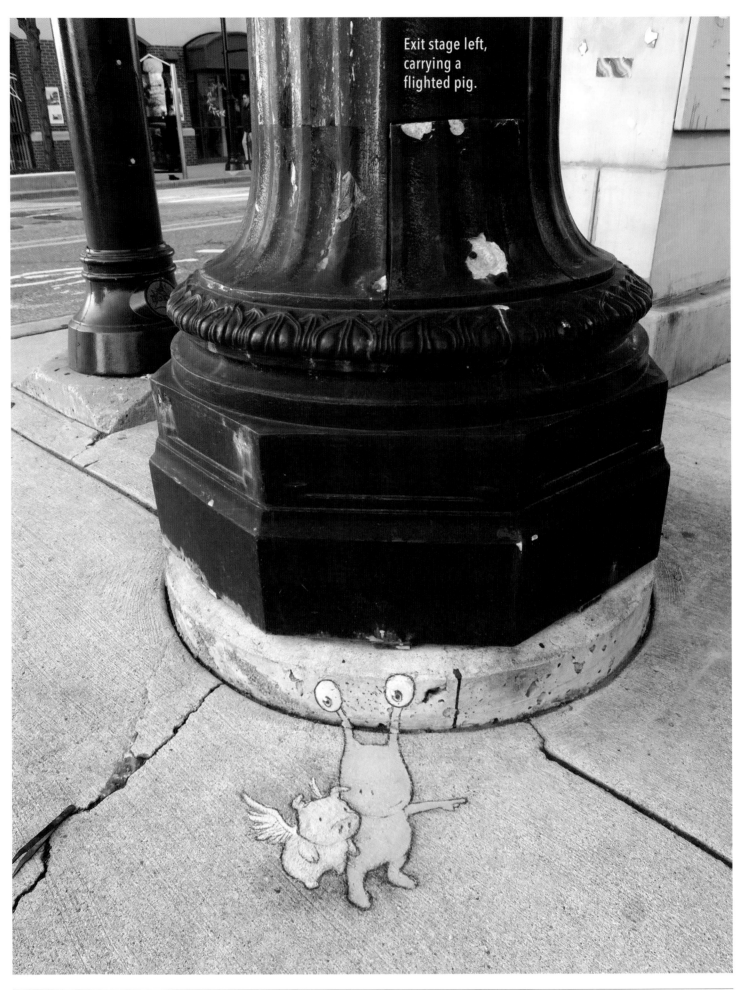

Exit stage left, carrying a flighted pig.

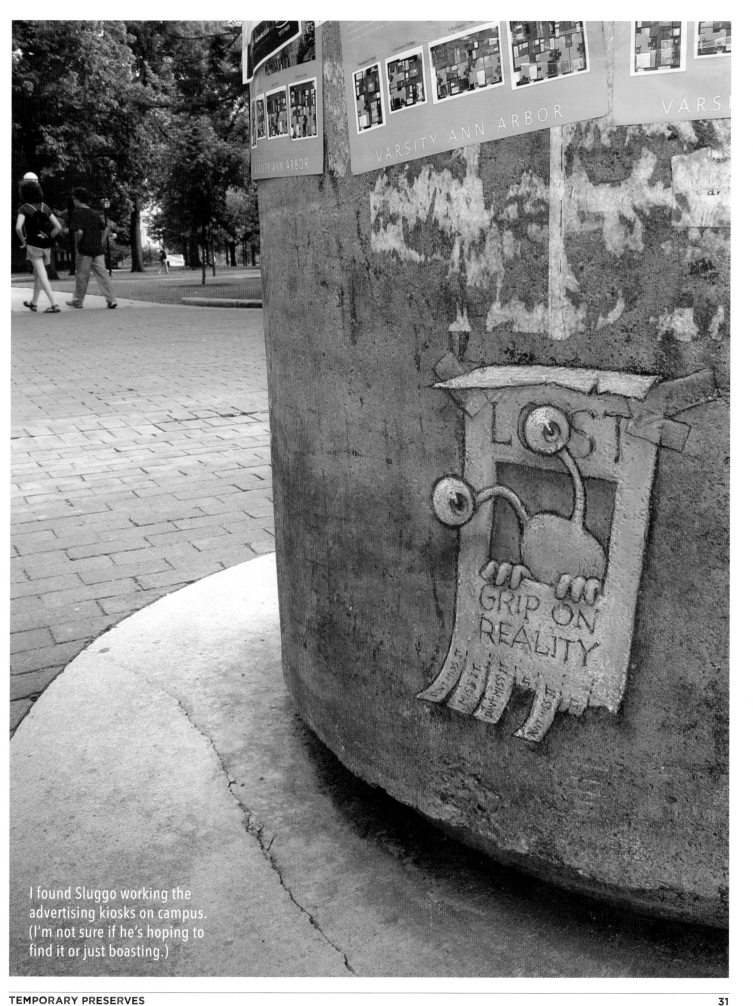

I found Sluggo working the advertising kiosks on campus. (I'm not sure if he's hoping to find it or just boasting.)

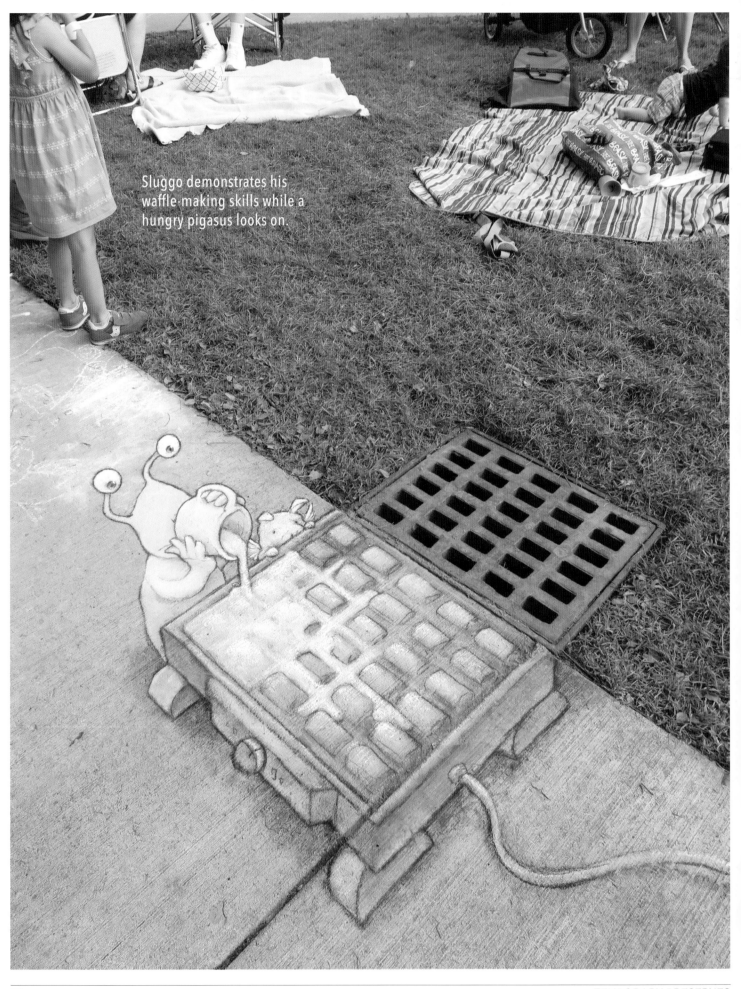

Sluggo demonstrates his waffle-making skills while a hungry pigasus looks on.

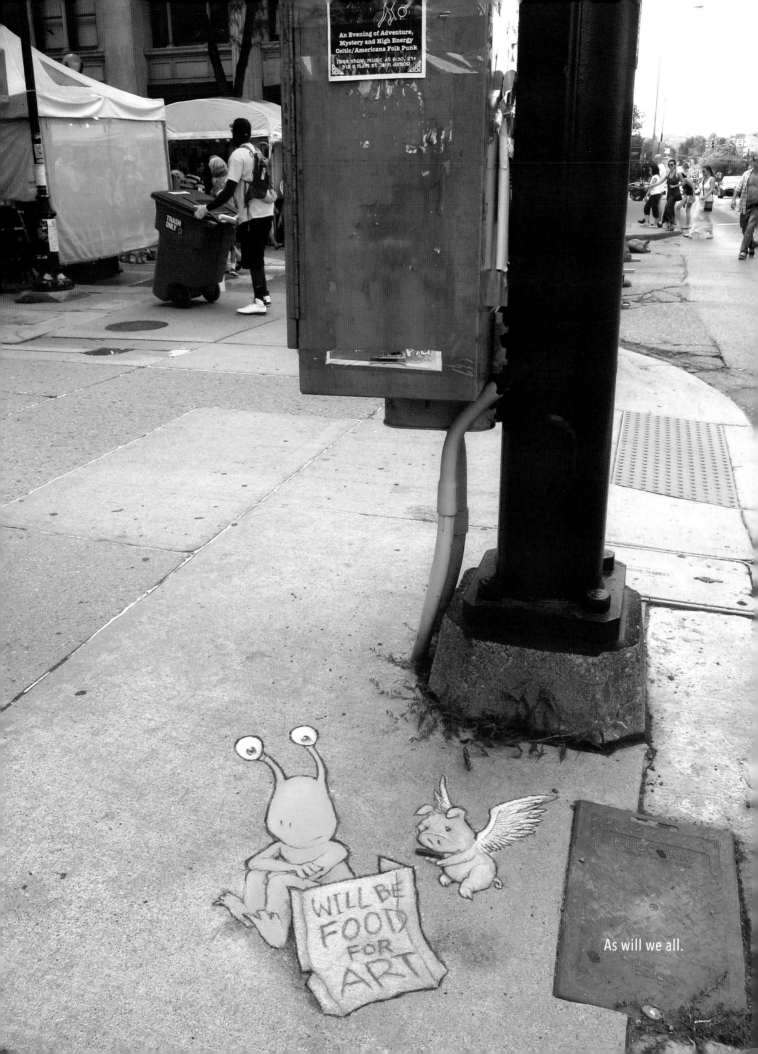

As will we all.

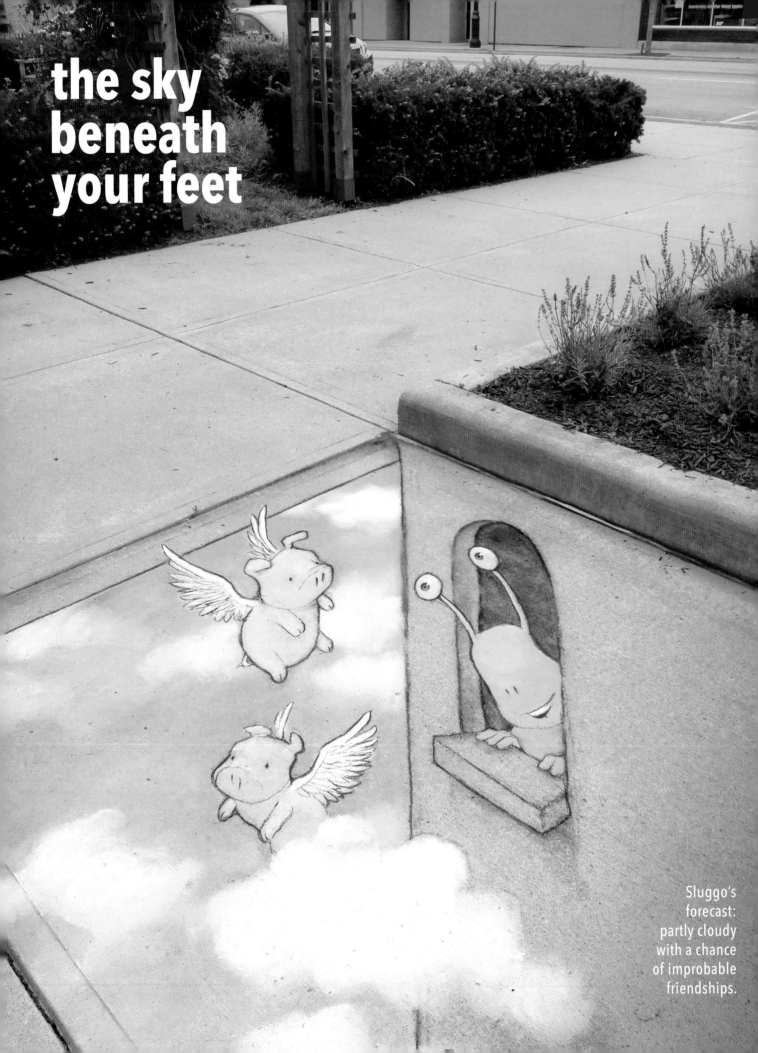

**the sky
beneath
your feet**

Sluggo's forecast: partly cloudy with a chance of improbable friendships.

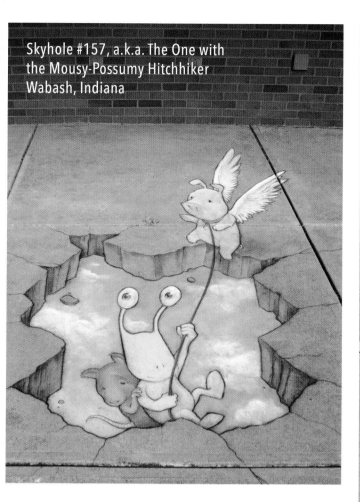

Skyhole #157, a.k.a. The One with the Mousy-Possumy Hitchhiker
Wabash, Indiana

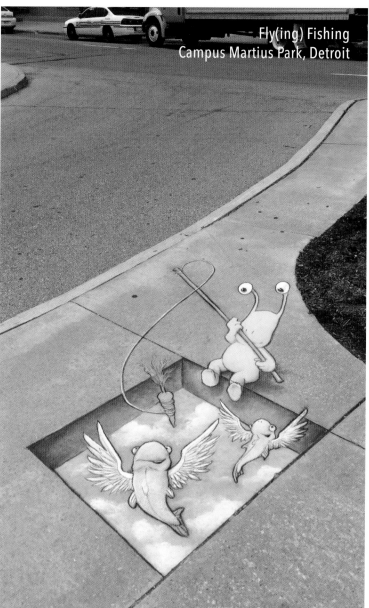

Fly(ing) Fishing
Campus Martius Park, Detroit

Making fake holes in the ground is a favorite trick of anamorphic (3-D) street artists. If you've seen a 3-D chalk drawing while browsing the Internet, chances are good that it involved some kind of revine, chasm, gorge, canyon or swimming pool. Mathematically, these holes are comparatively easy to draw – especially if there are already cracks in the sidewalk that can be "borrowed" for the purpose – and they lend themselves to the ever-popular "Aah! I'm going to fall in!" variety of photo op.

The Artist in me tries to resist this low-hanging fruit, but my inner child (who is far more likely to be holding the chalk) can't leave them alone; they're too much fun to draw. I've frittered away countless hours of creative opportunities indulging in fishing holes, surprised moles, swimming dragons, and successful hunts for buried treasure. Of all the many illusionary options, filling these holes with blue sky makes me happiest. On the one hand, it's the most unbelievable and vertigo-inducing thing to imagine on the other side of the sidewalk, but it's also the most true. Admittedly, I'm fudging the distance by a few thousand miles, but if you really think about it, what is there more of under your feet right now: solid ground or open space?

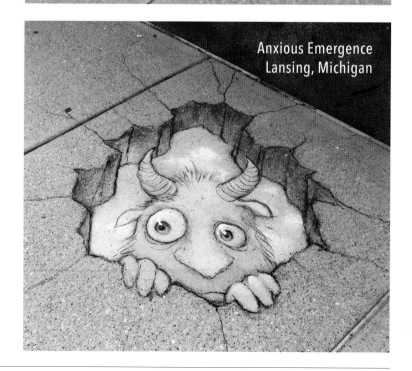

Anxious Emergence
Lansing, Michigan

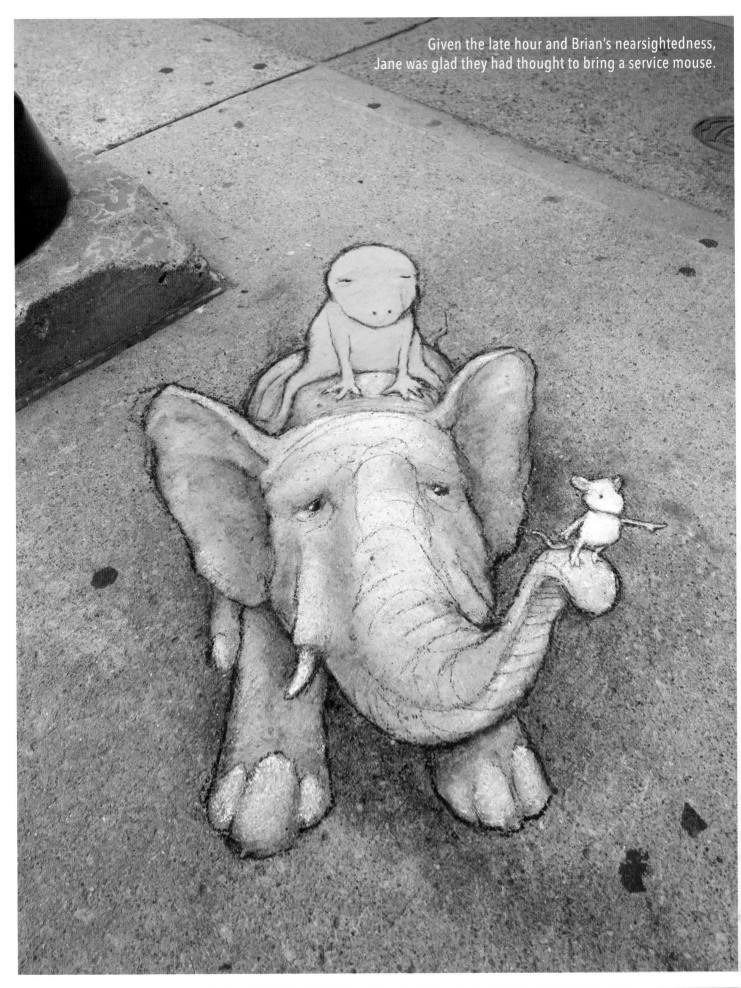

Given the late hour and Brian's nearsightedness,
Jane was glad they had thought to bring a service mouse.

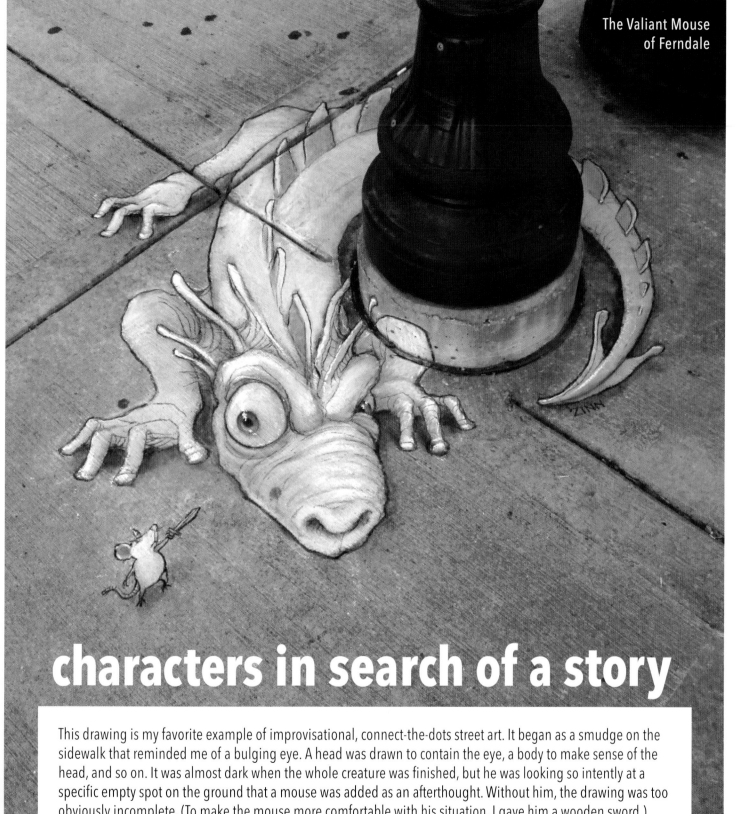

characters in search of a story

This drawing is my favorite example of improvisational, connect-the-dots street art. It began as a smudge on the sidewalk that reminded me of a bulging eye. A head was drawn to contain the eye, a body to make sense of the head, and so on. It was almost dark when the whole creature was finished, but he was looking so intently at a specific empty spot on the ground that a mouse was added as an afterthought. Without him, the drawing was too obviously incomplete. (To make the mouse more comfortable with his situation, I gave him a wooden sword.)

Whatever story is being told here, I didn't write it; I was just trying to make use of an eye-shaped smudge. Luckily, adventures are in the mind of the beholder. When I ask kids what they think is going on in this picture, 90% say that a brave mouse is fighting an evil dragon, 9% say a baby dragon is being attacked by an evil mouse, and a five-year-old future novelist once told me that the mouse is a dentist.

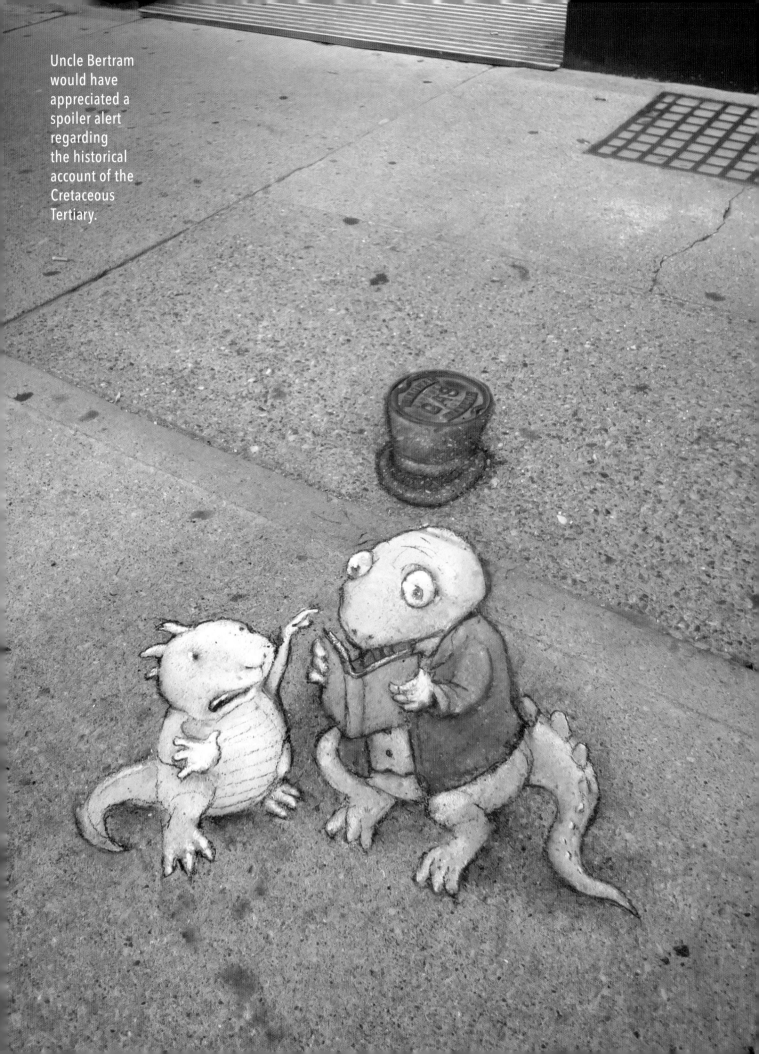

Uncle Bertram would have appreciated a spoiler alert regarding the historical account of the Cretaceous Tertiary.

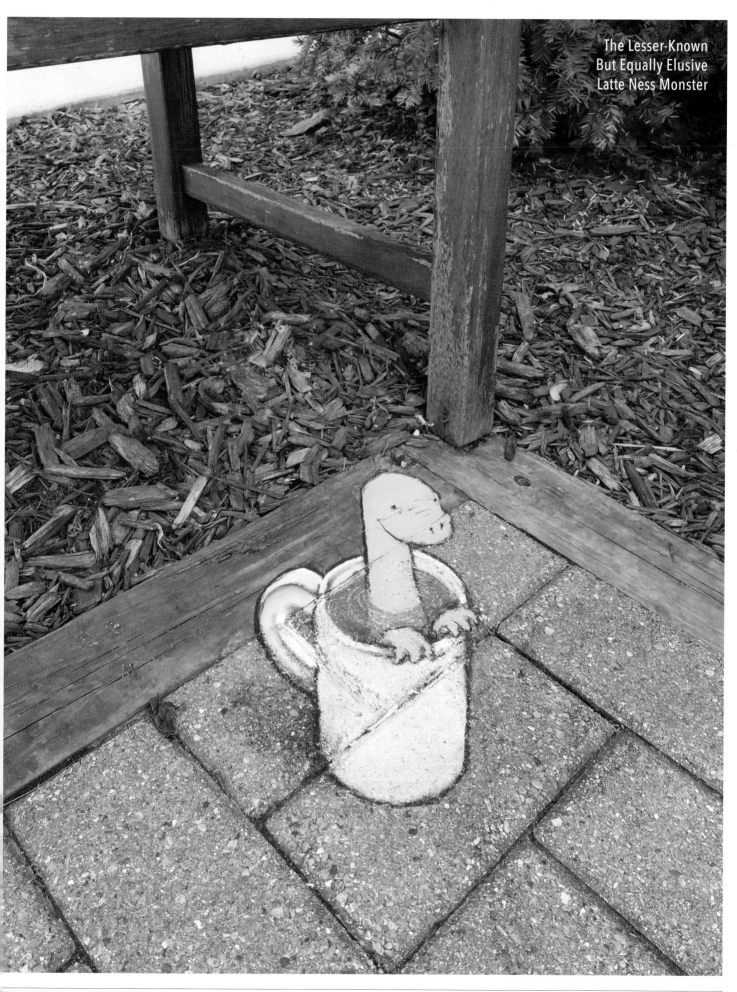

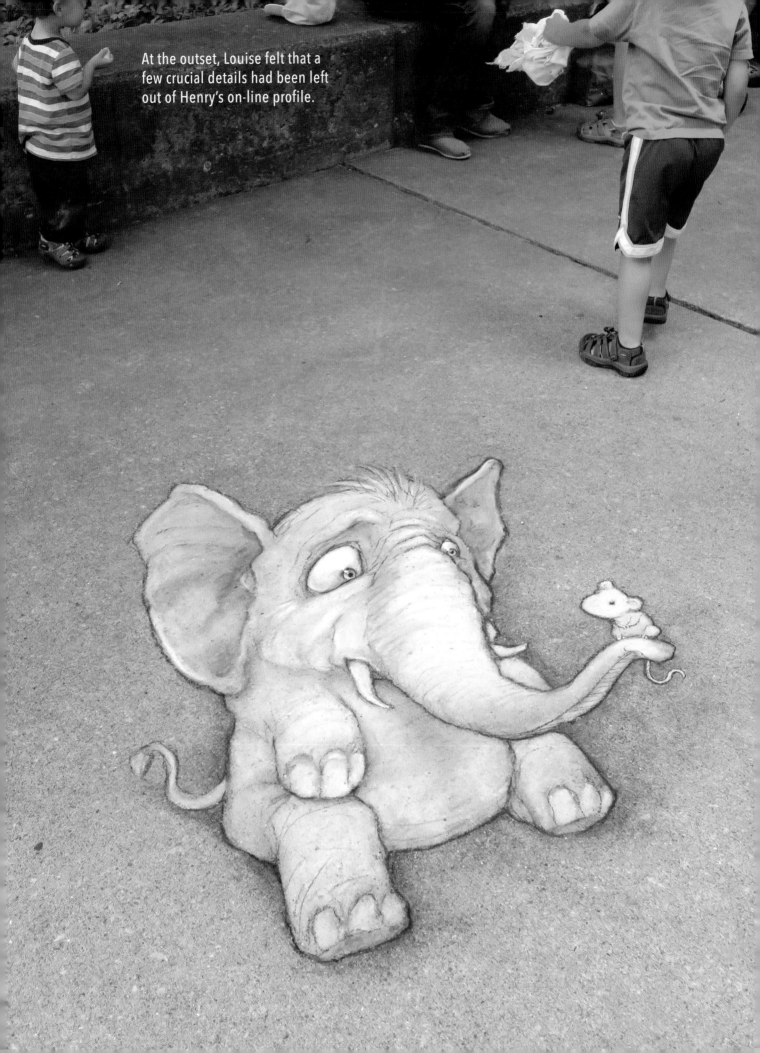

At the outset, Louise felt that a few crucial details had been left out of Henry's on-line profile.

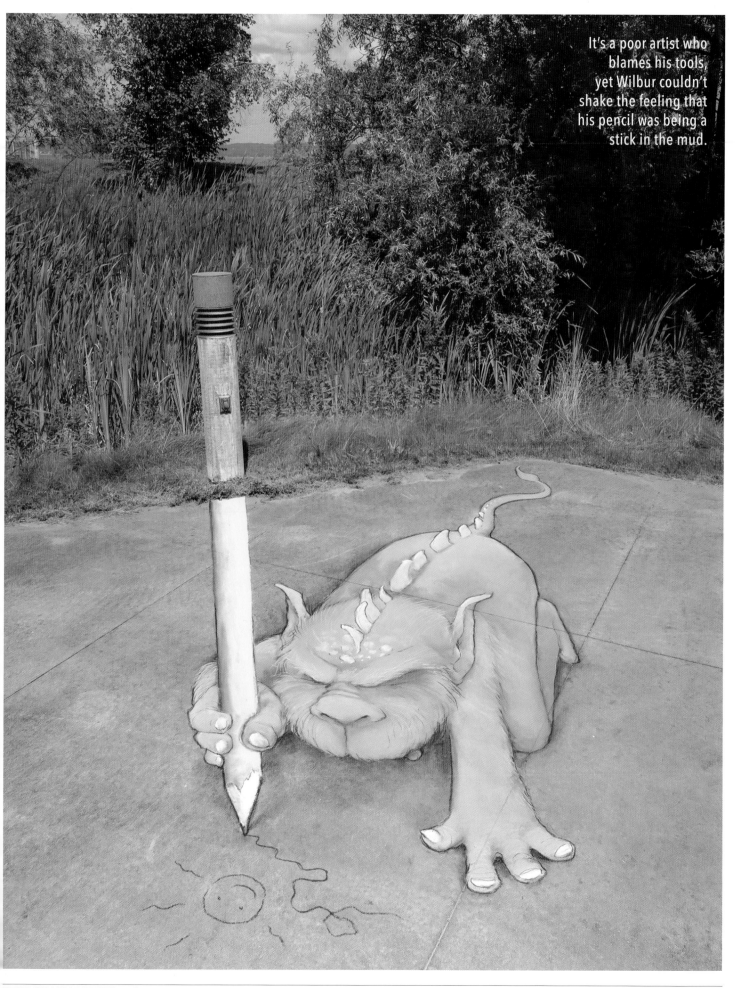

It's a poor artist who blames his tools, yet Wilbur couldn't shake the feeling that his pencil was being a stick in the mud.

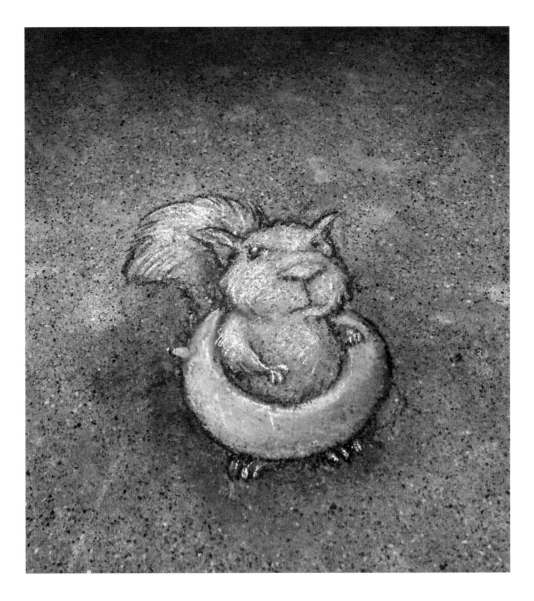

"Pecans" McGrough was led to believe
that there would be a pool at this party.

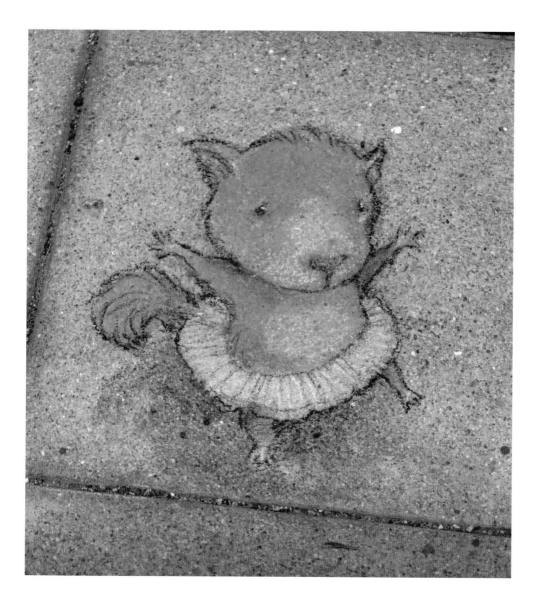

Hervé could no longer remember if he had found the tutu because he danced,
or danced because he had found a tutu. C'est la vie.

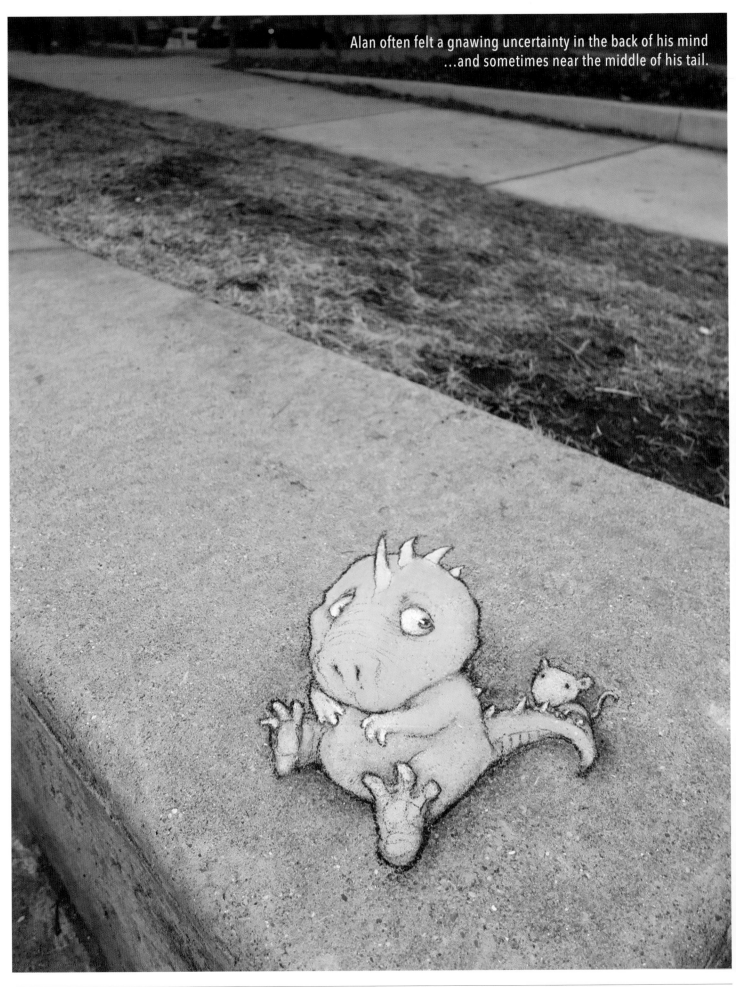

Alan often felt a gnawing uncertainty in the back of his mind
...and sometimes near the middle of his tail.

TEMPORARY PRESERVES

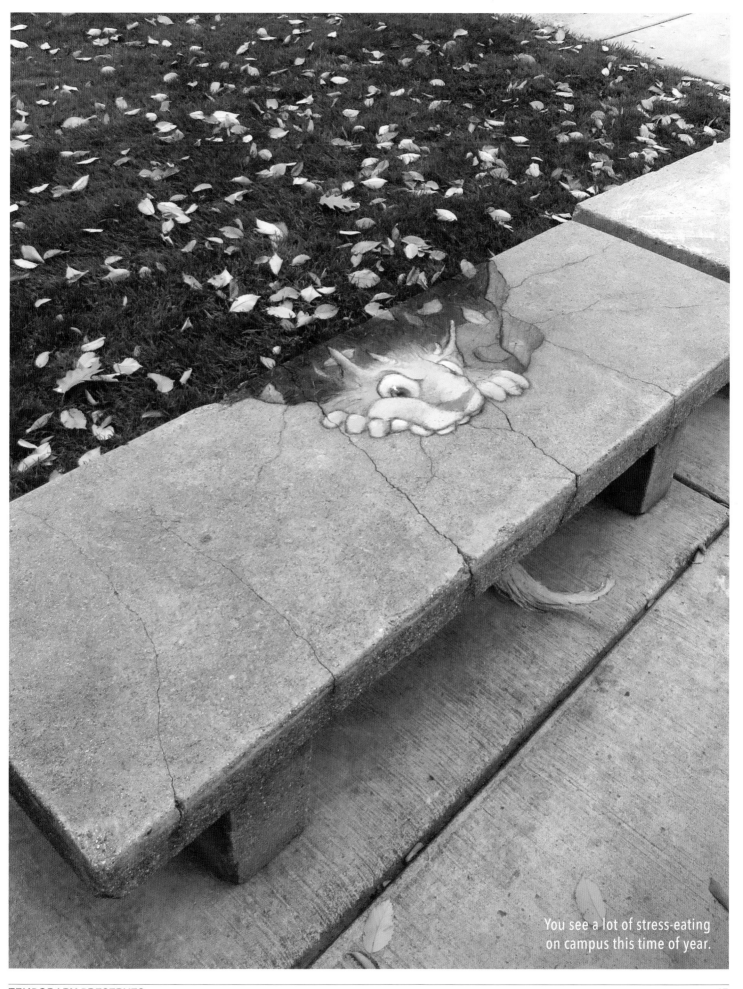

You see a lot of stress-eating
on campus this time of year.

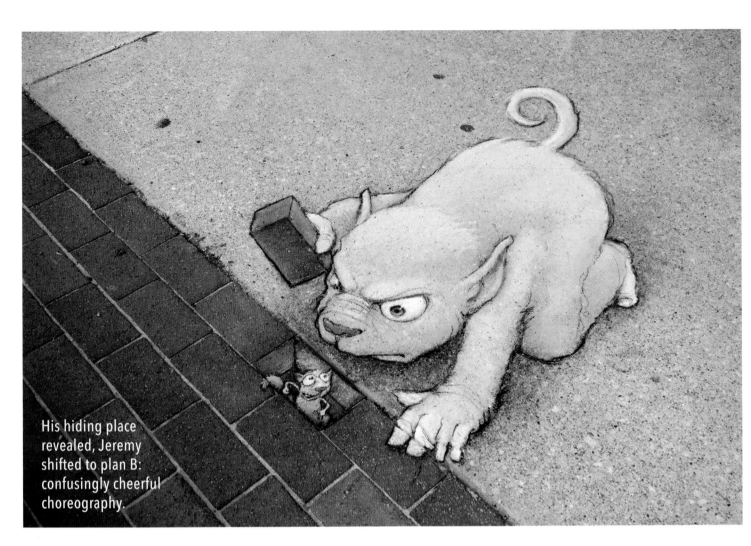

His hiding place revealed, Jeremy shifted to plan B: confusingly cheerful choreography.

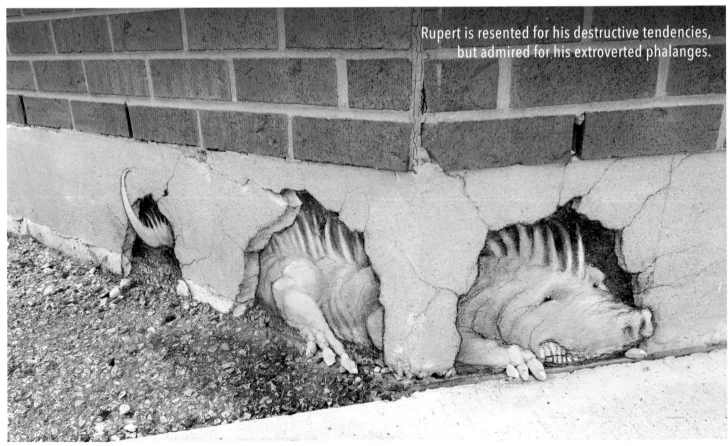

Rupert is resented for his destructive tendencies, but admired for his extroverted phalanges.

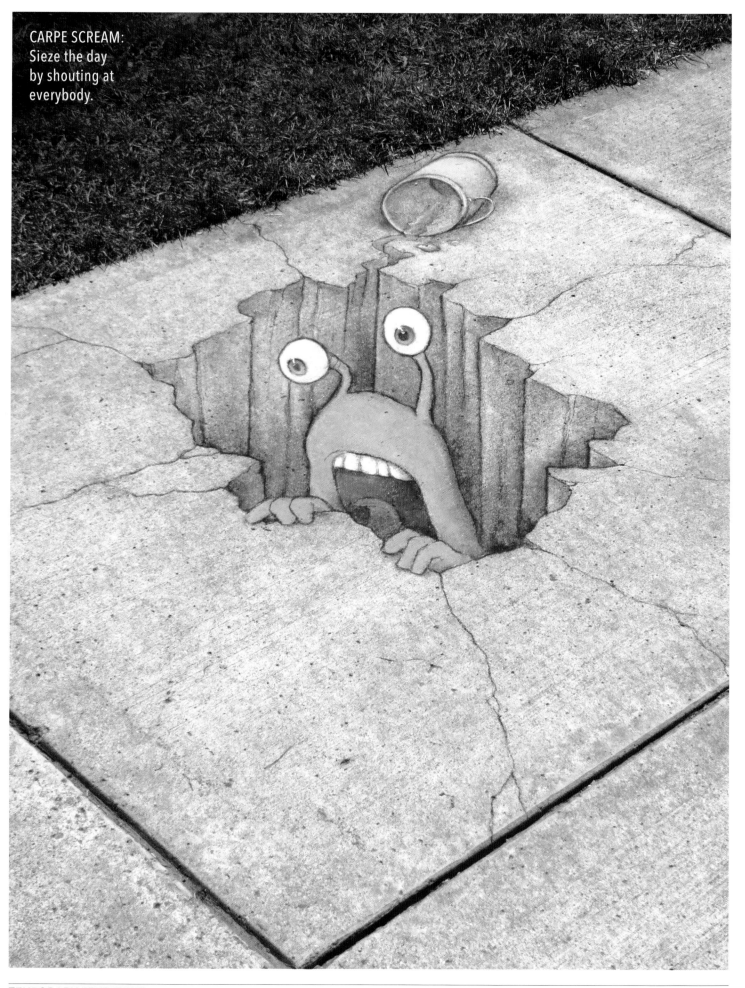

CARPE SCREAM:
Sieze the day
by shouting at
everybody.

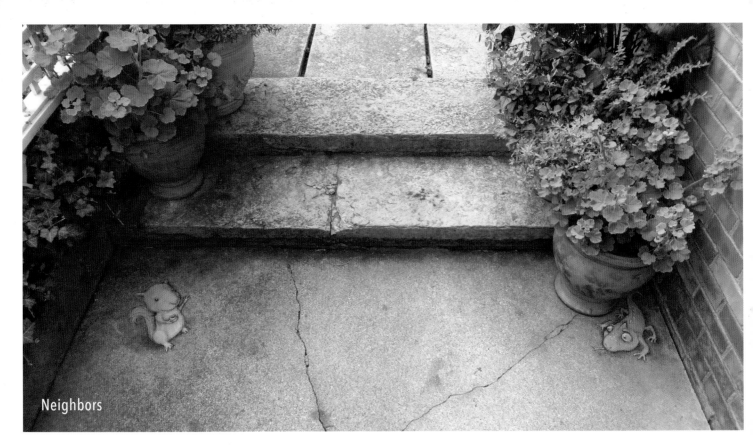

Neighbors

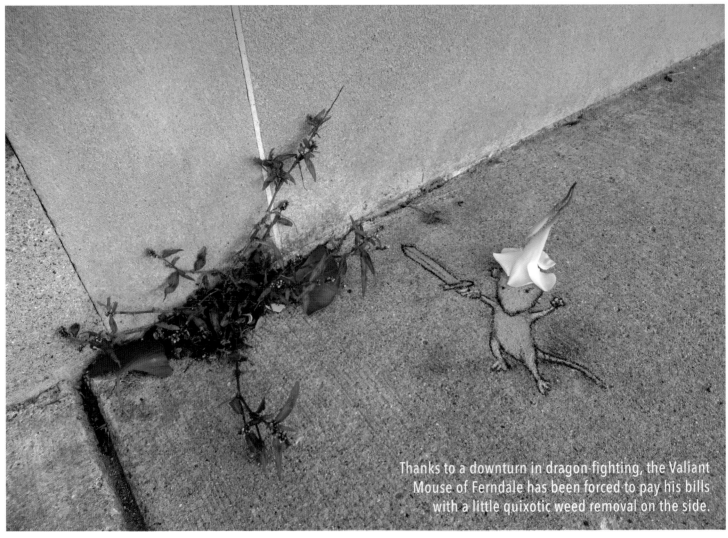

Thanks to a downturn in dragon-fighting, the Valiant
Mouse of Ferndale has been forced to pay his bills
with a little quixotic weed removal on the side.

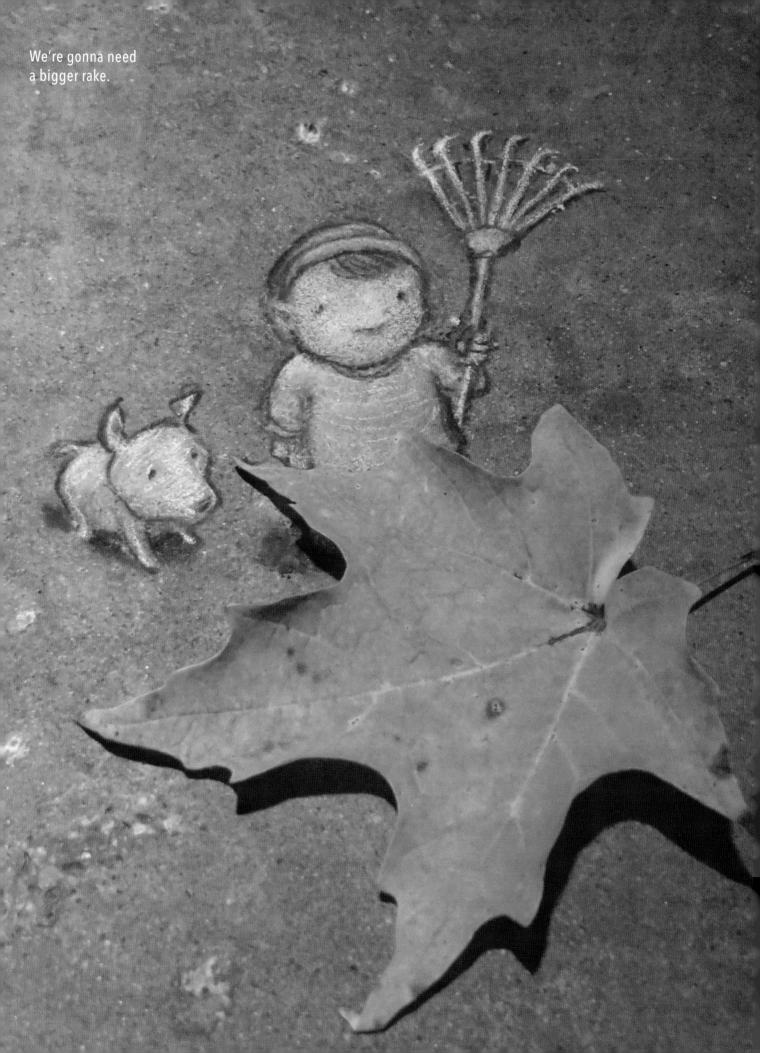

We're gonna need
a bigger rake.

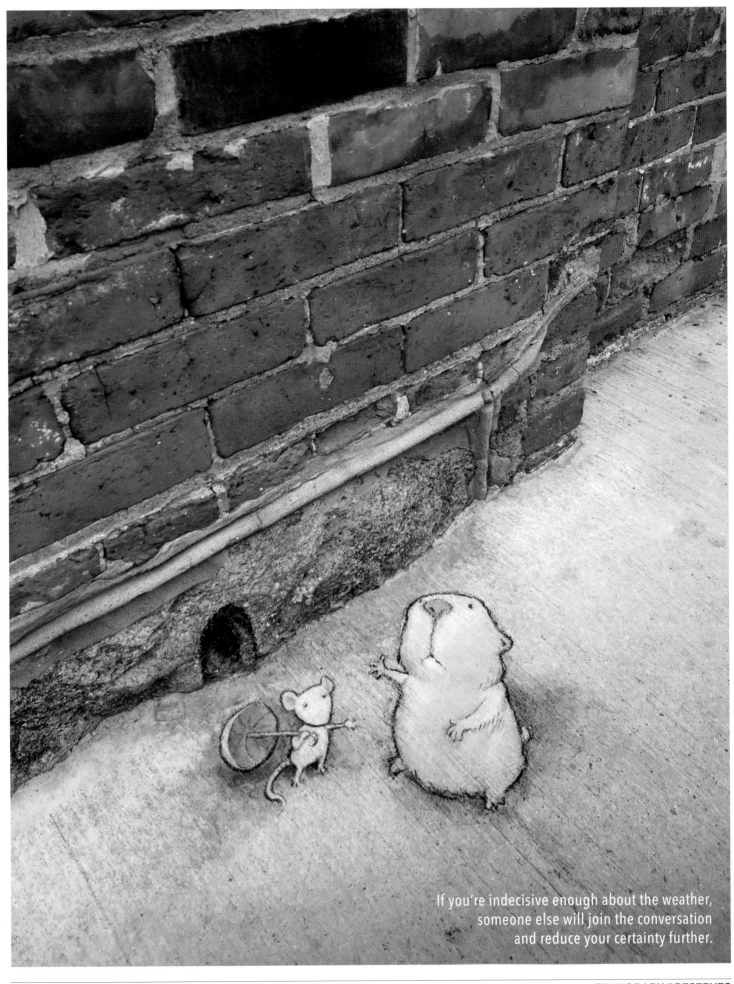

If you're indecisive enough about the weather, someone else will join the conversation and reduce your certainty further.

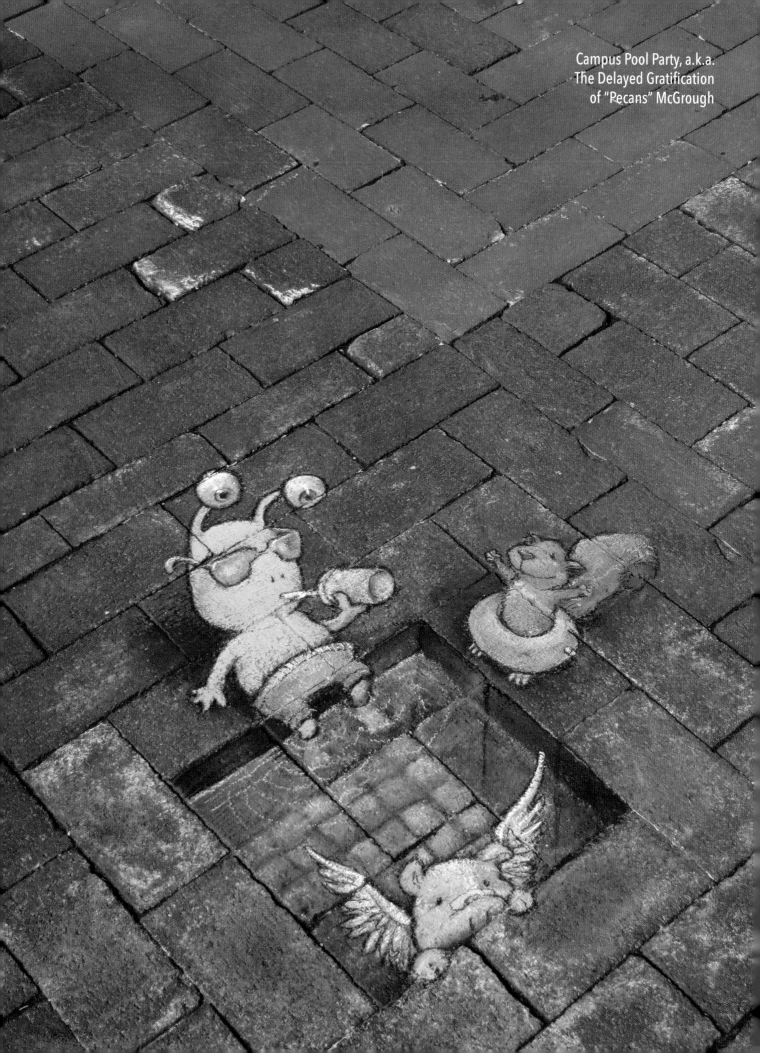

Campus Pool Party, a.k.a.
The Delayed Gratification
of "Pecans" McGrough

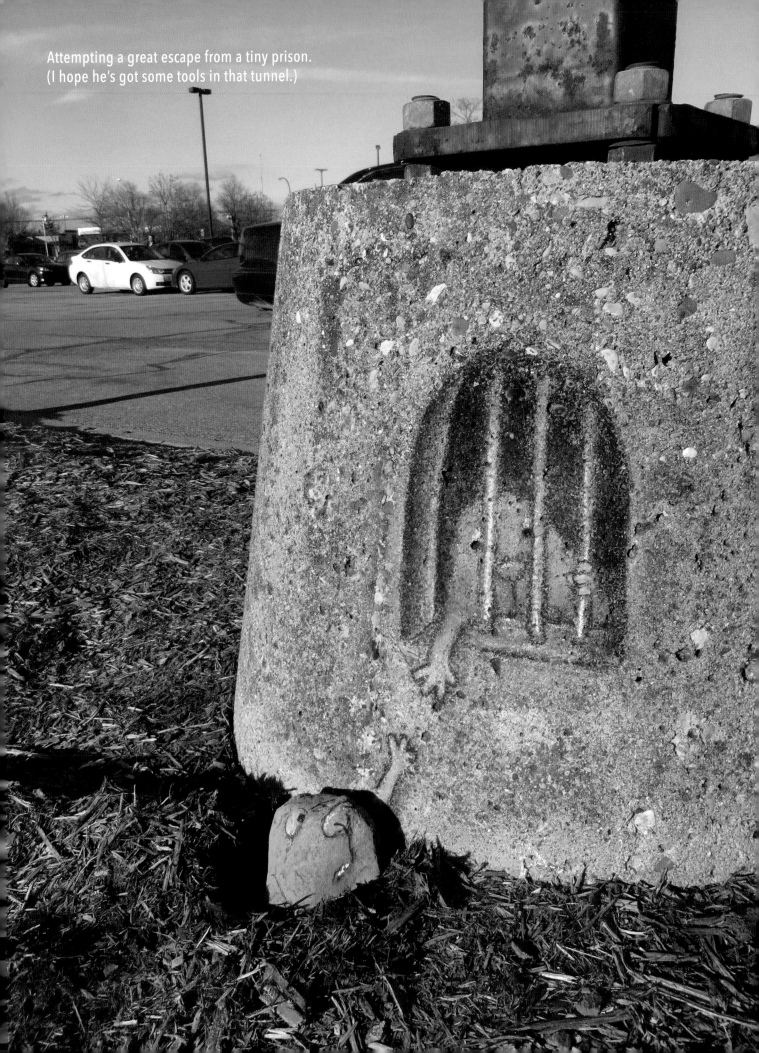

Attempting a great escape from a tiny prison.
(I hope he's got some tools in that tunnel.)

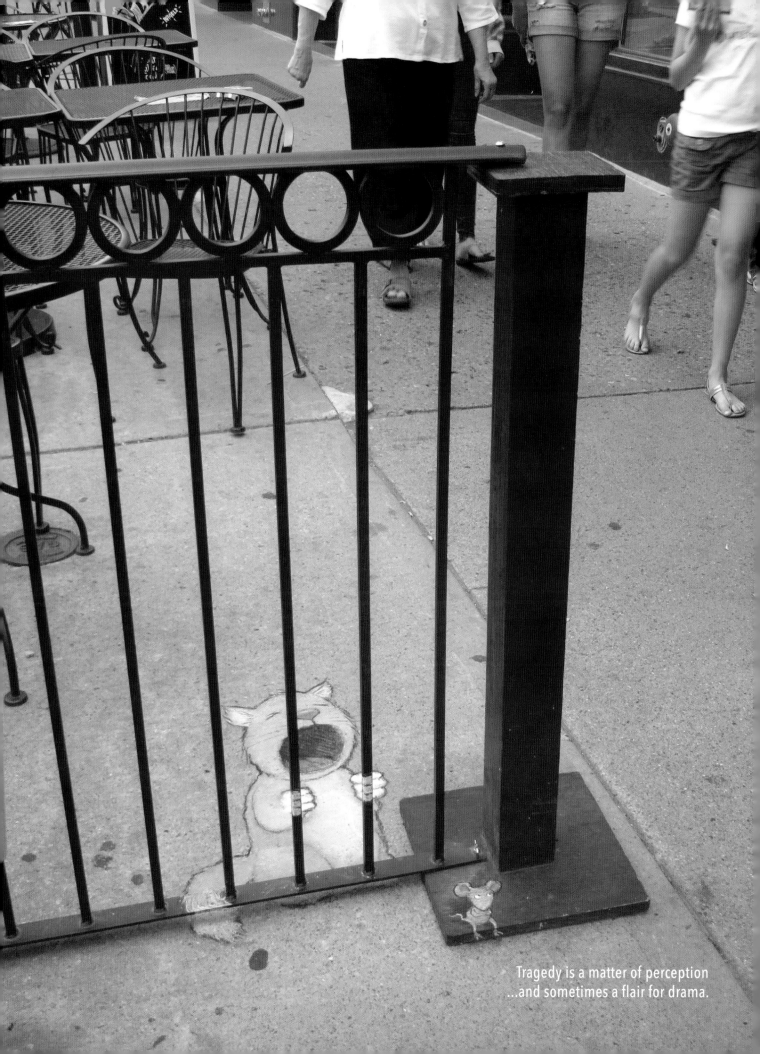

Tragedy is a matter of perception
...and sometimes a flair for drama.

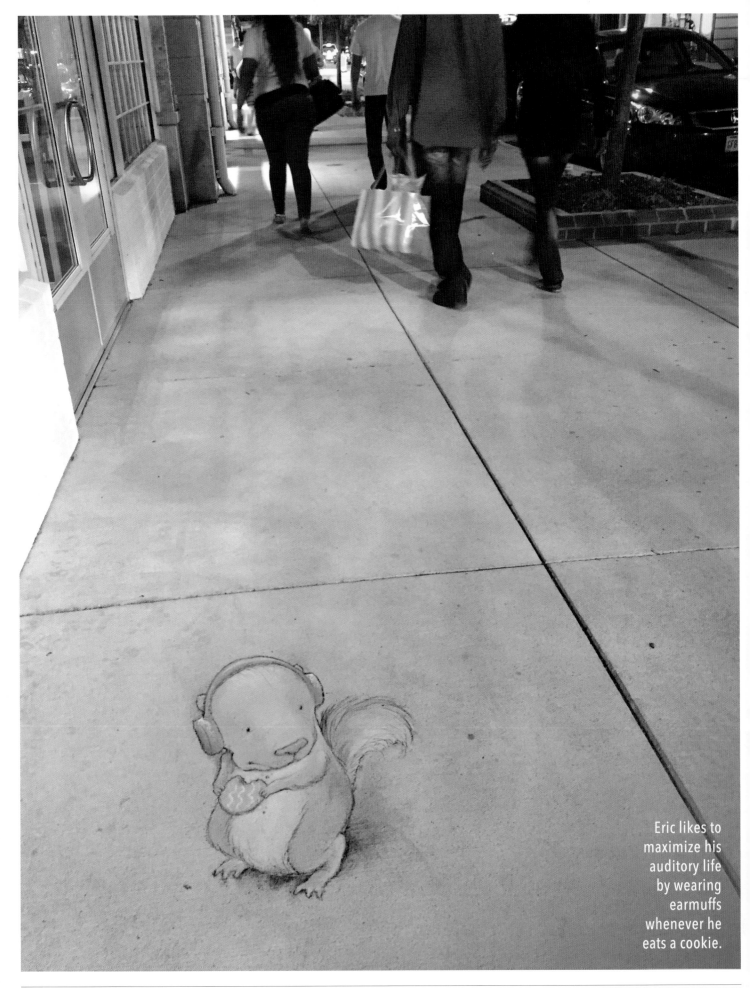

Eric likes to
maximize his
auditory life
by wearing
earmuffs
whenever he
eats a cookie.

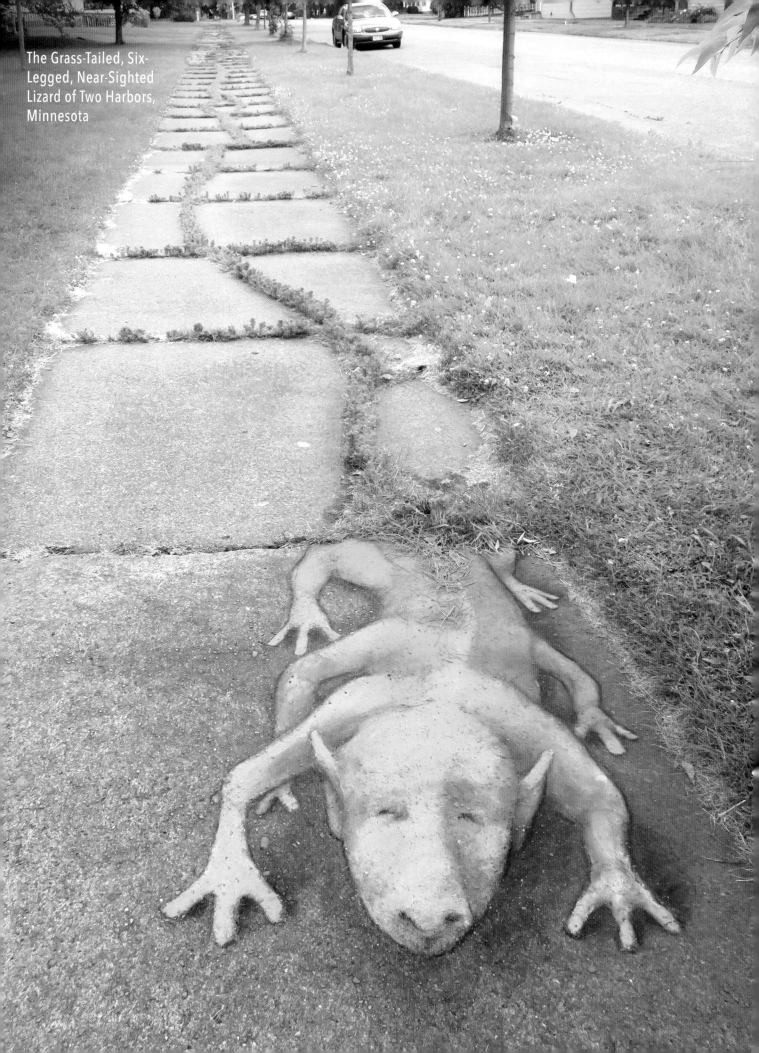

The Grass-Tailed, Six-Legged, Near-Sighted Lizard of Two Harbors, Minnesota

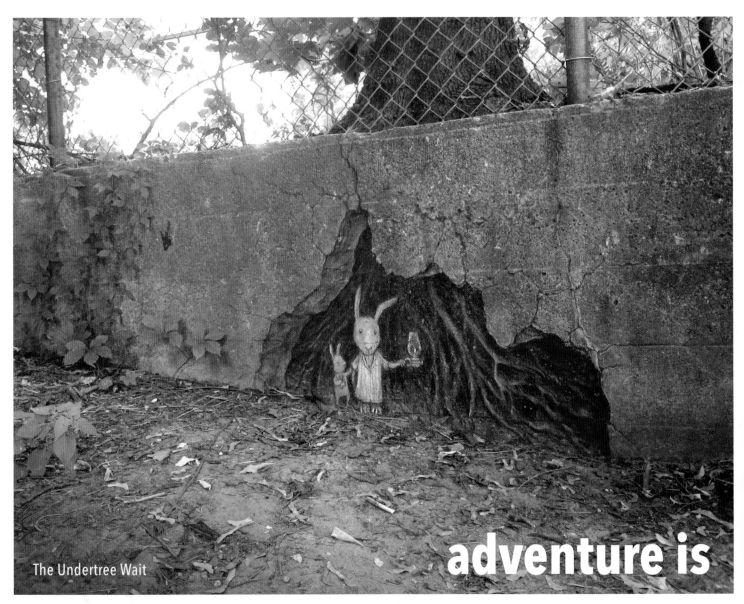

The Undertree Wait

adventure is

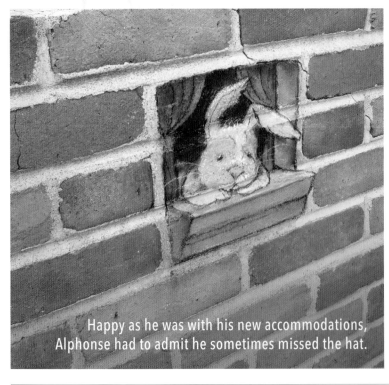

Happy as he was with his new accommodations, Alphonse had to admit he sometimes missed the hat.

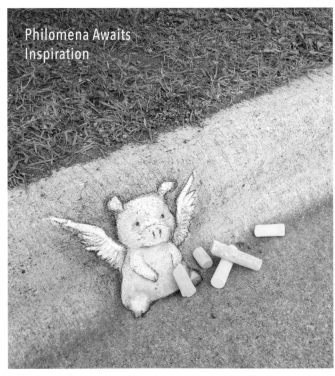

Philomena Awaits Inspiration

TEMPORARY PRESERVES

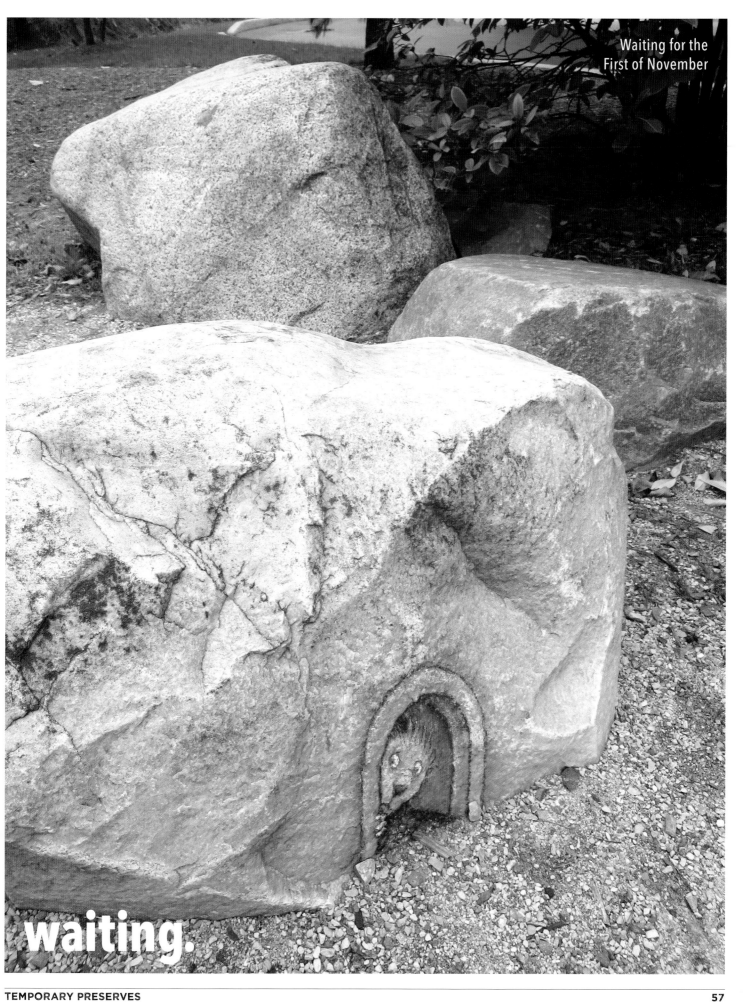

waiting.

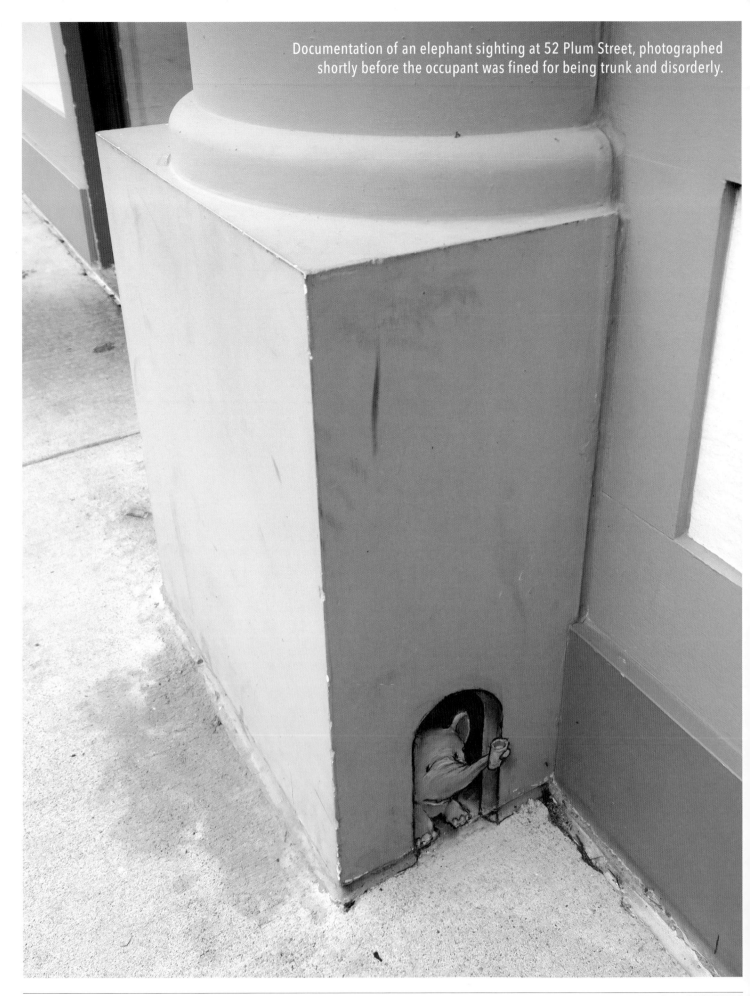

Documentation of an elephant sighting at 52 Plum Street, photographed shortly before the occupant was fined for being trunk and disorderly.

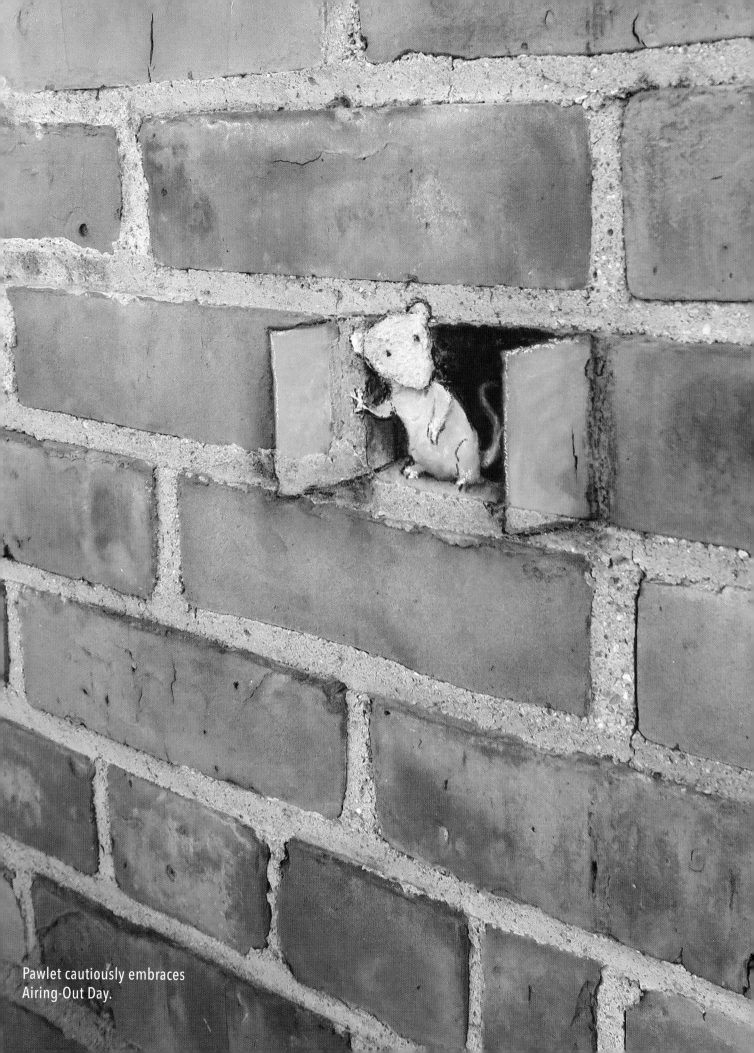

Pawlet cautiously embraces
Airing-Out Day.

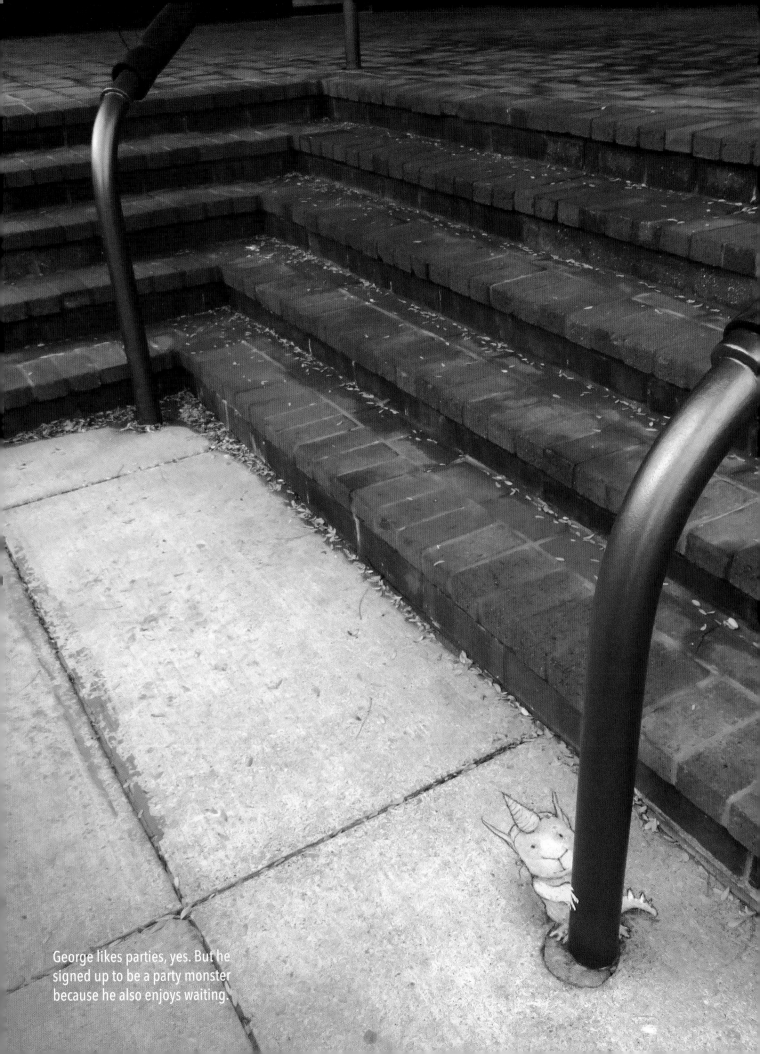

George likes parties, yes. But he signed up to be a party monster because he also enjoys waiting.

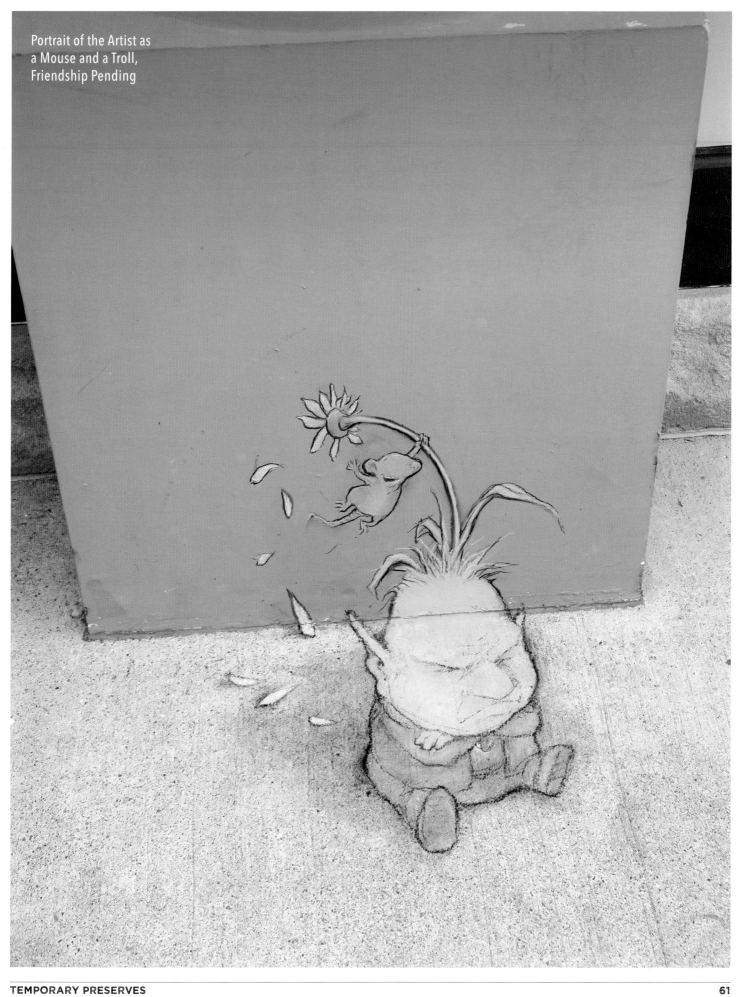

Portrait of the Artist as
a Mouse and a Troll,
Friendship Pending

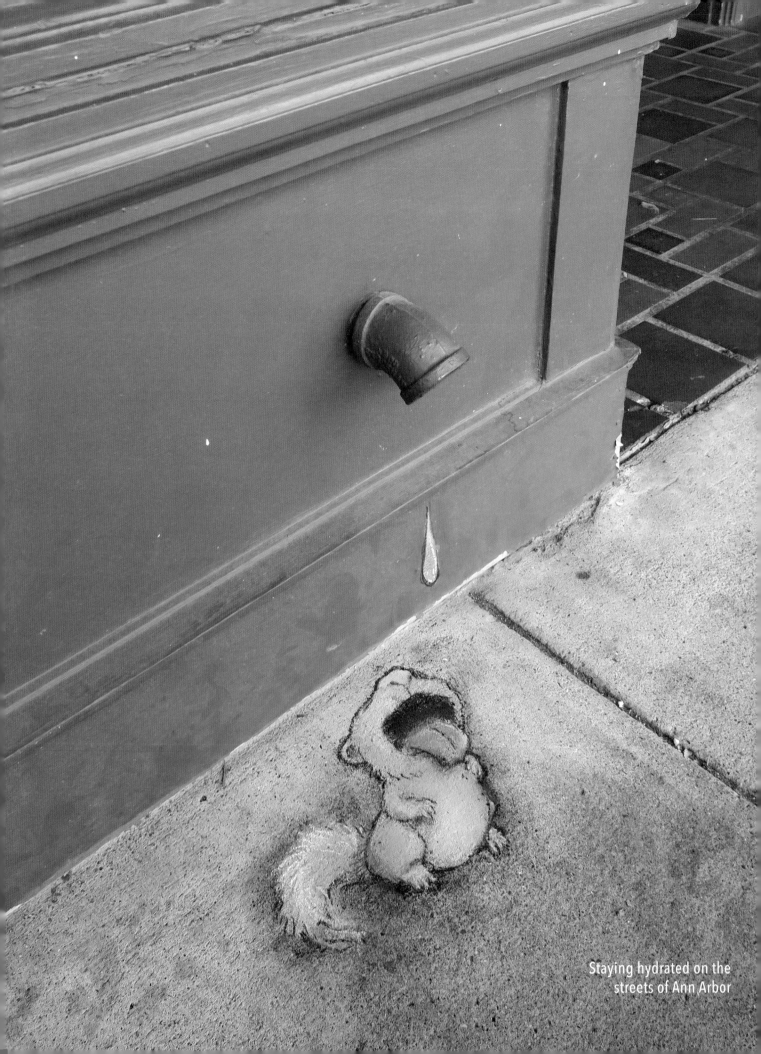

Staying hydrated on the
streets of Ann Arbor

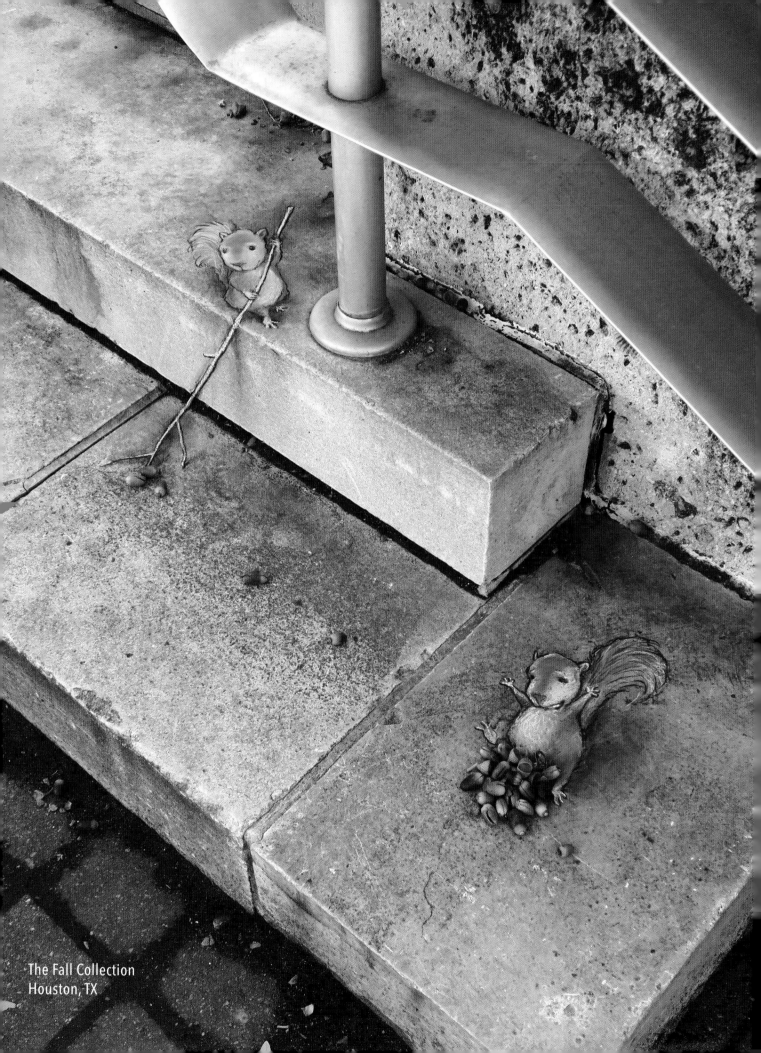

The Fall Collection
Houston, TX

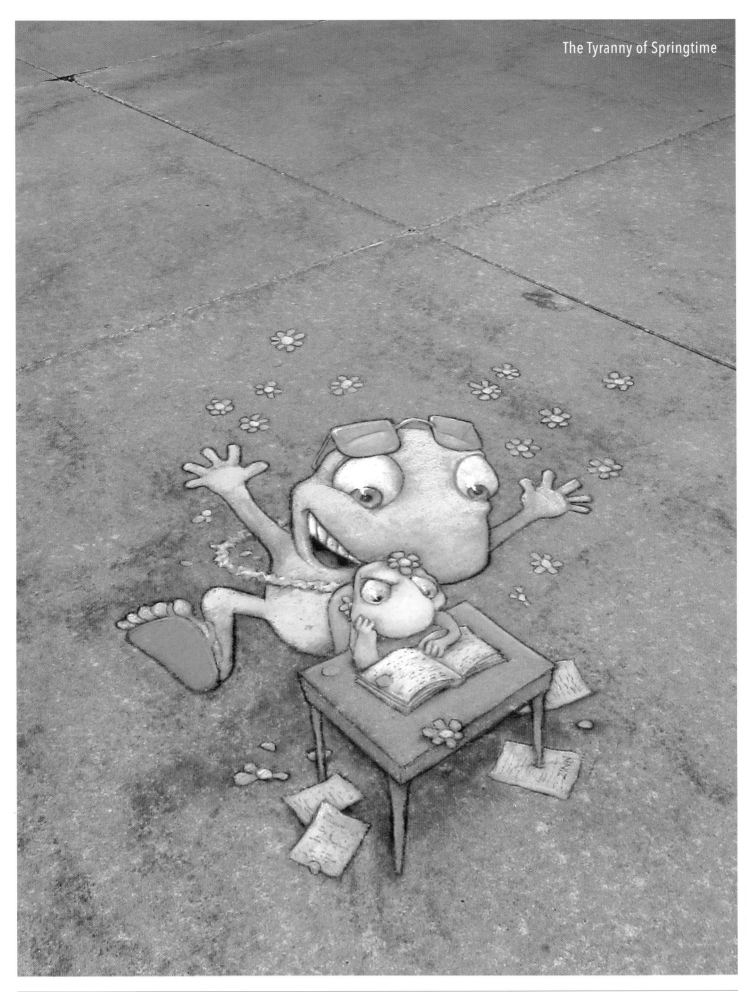

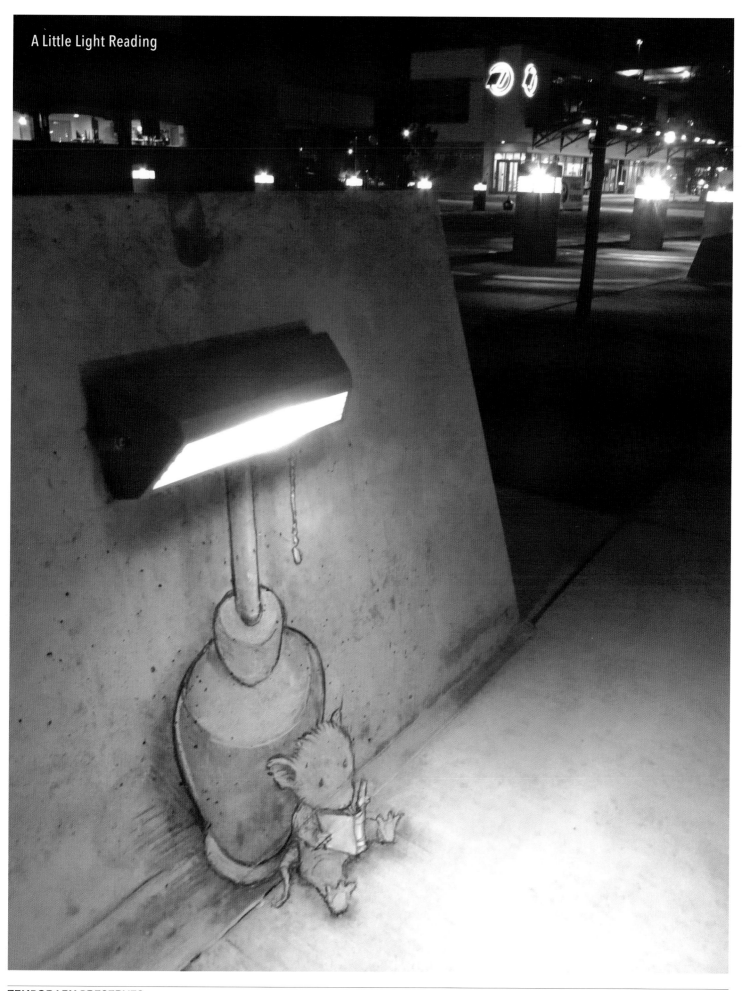

A Little Light Reading

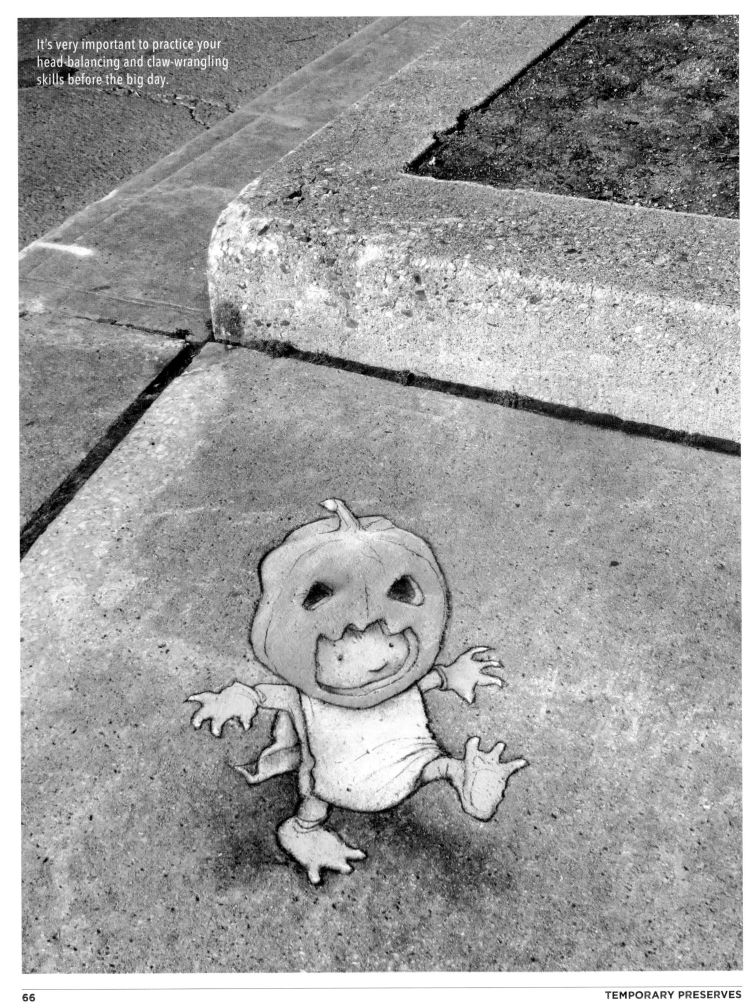

It's very important to practice your head-balancing and claw-wrangling skills before the big day.

TEMPORARY PRESERVES

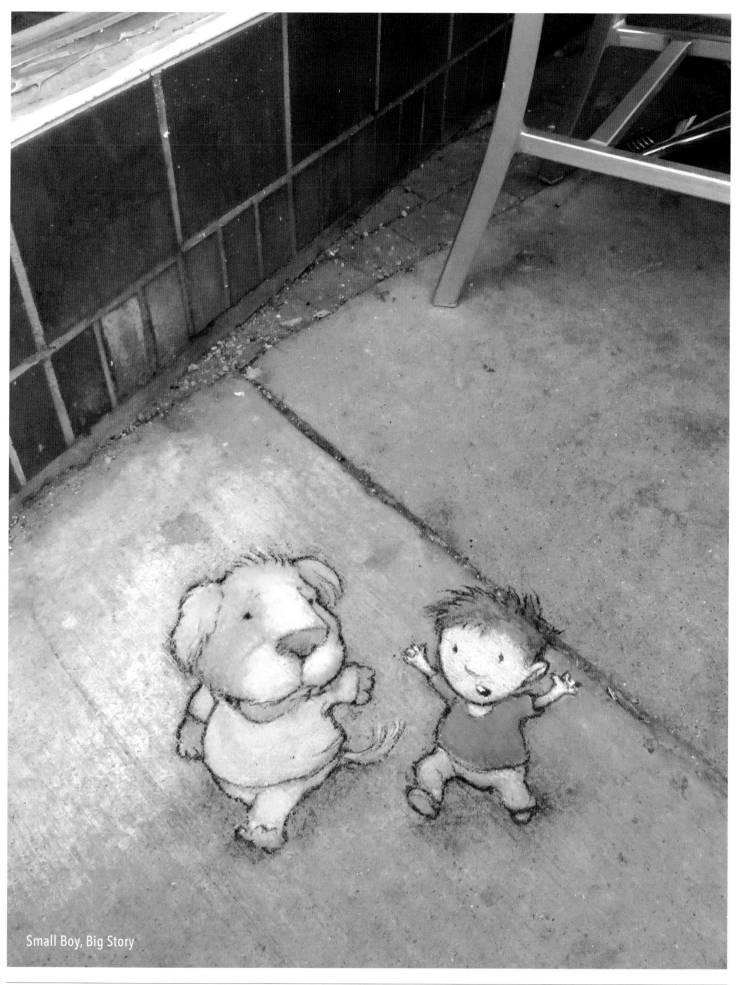

Small Boy, Big Story

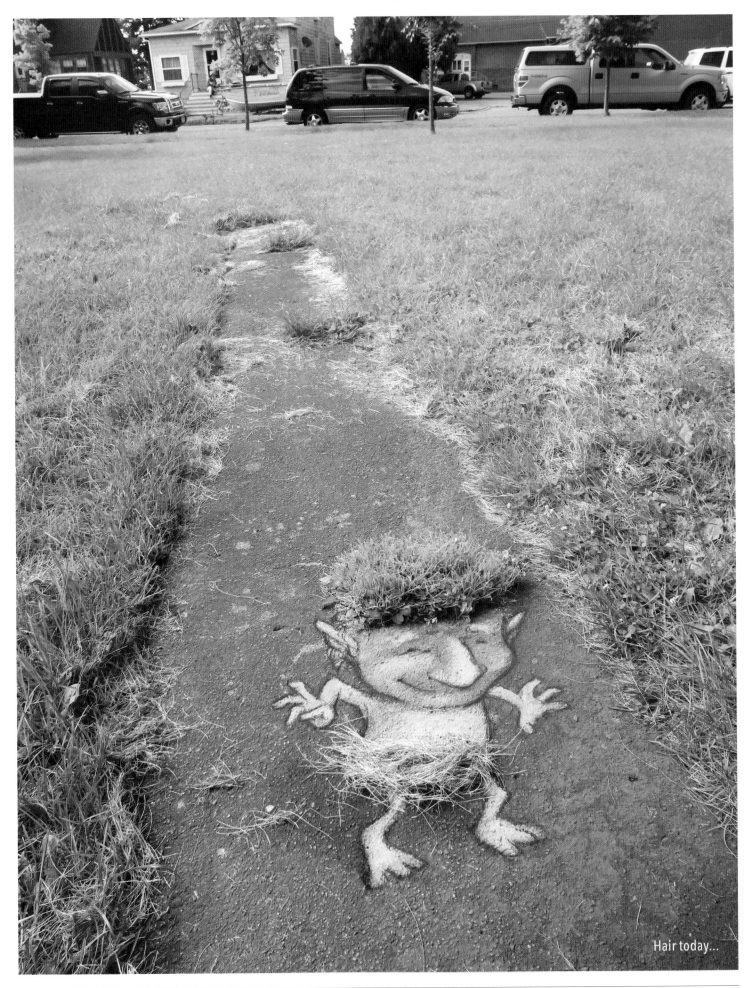

Hair today...

TEMPORARY PRESERVES

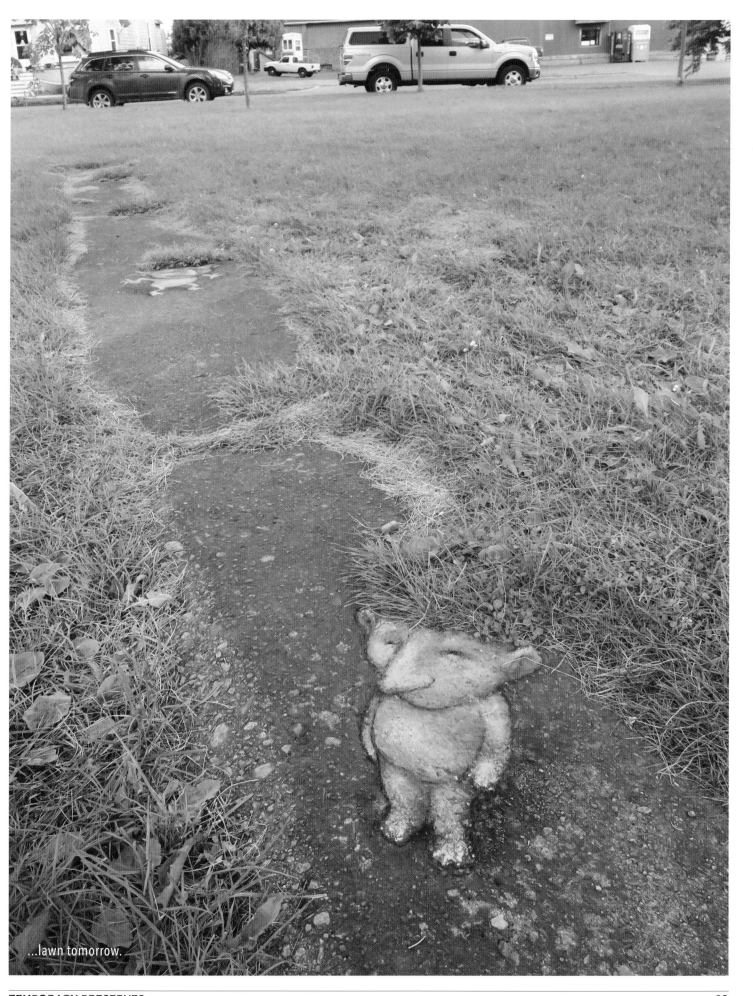

...lawn tomorrow.

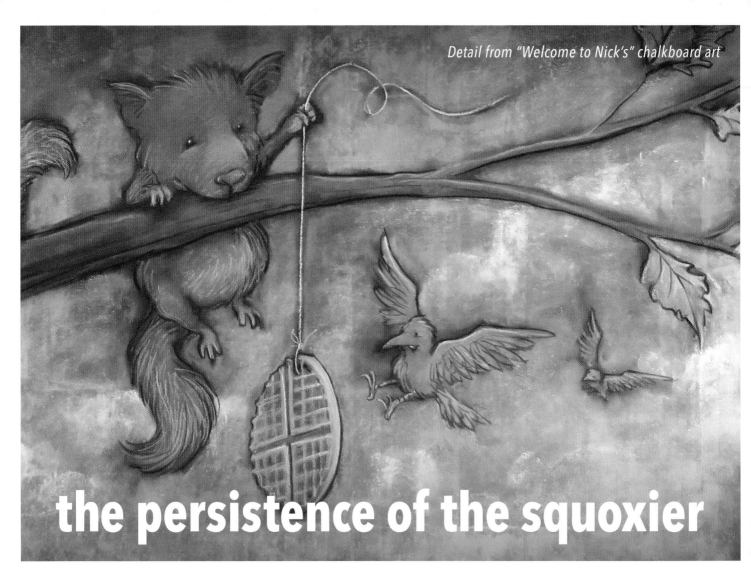

the persistence of the squoxier

I started chalking monsters for a very specific reason: real animals are harder to draw. With an imaginary creature – especially a green or scaly one – you can meander along putting claws and elbows and eyeballs wherever you want, and no one will tell you that you made a mistake or ask if you meant to draw something else. When I try to draw furry creatures, however, they often fail to reach that imaginary monster status and instead become failed attempts to draw a squirrel, a fox, and a terrier, all at the same time. It's very frustrating.

Sometimes I can pretend I was trying to draw a wombat, and once or twice the accidental similarity to a quokka* has been eerie. Otherwise, to cover my trail of inattentive mammal biology, I call them squoxiers.

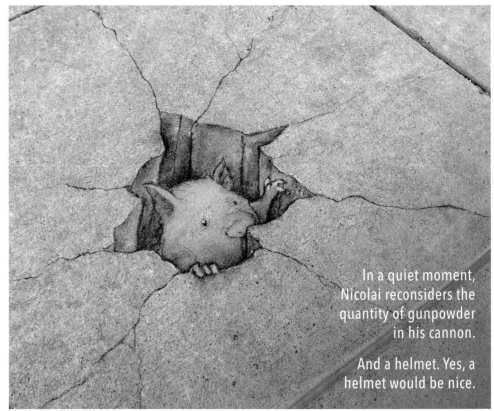

In a quiet moment, Nicolai reconsiders the quantity of gunpowder in his cannon.

And a helmet. Yes, a helmet would be nice.

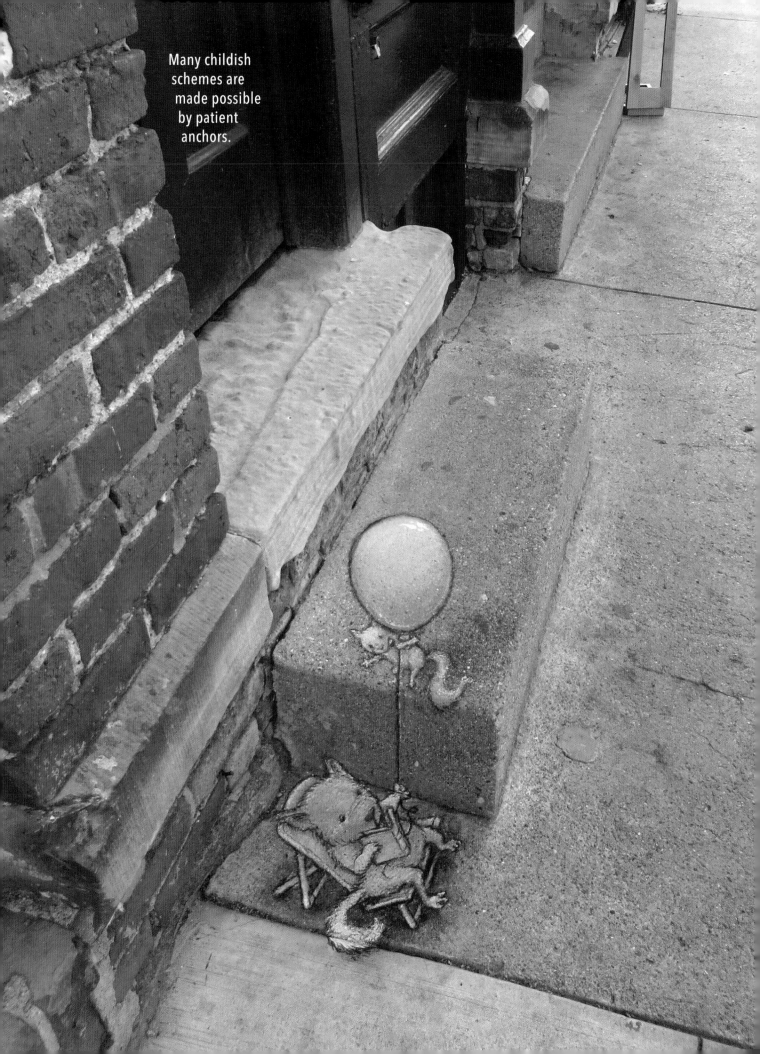

Many childish
schemes are
made possible
by patient
anchors.

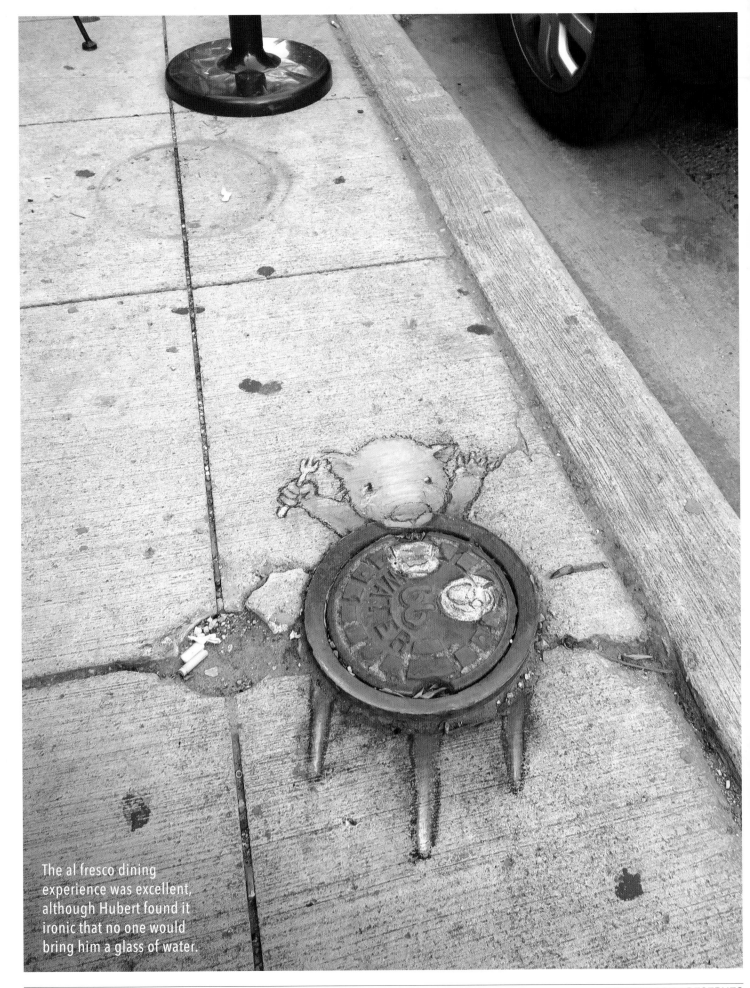

The al fresco dining experience was excellent, although Hubert found it ironic that no one would bring him a glass of water.

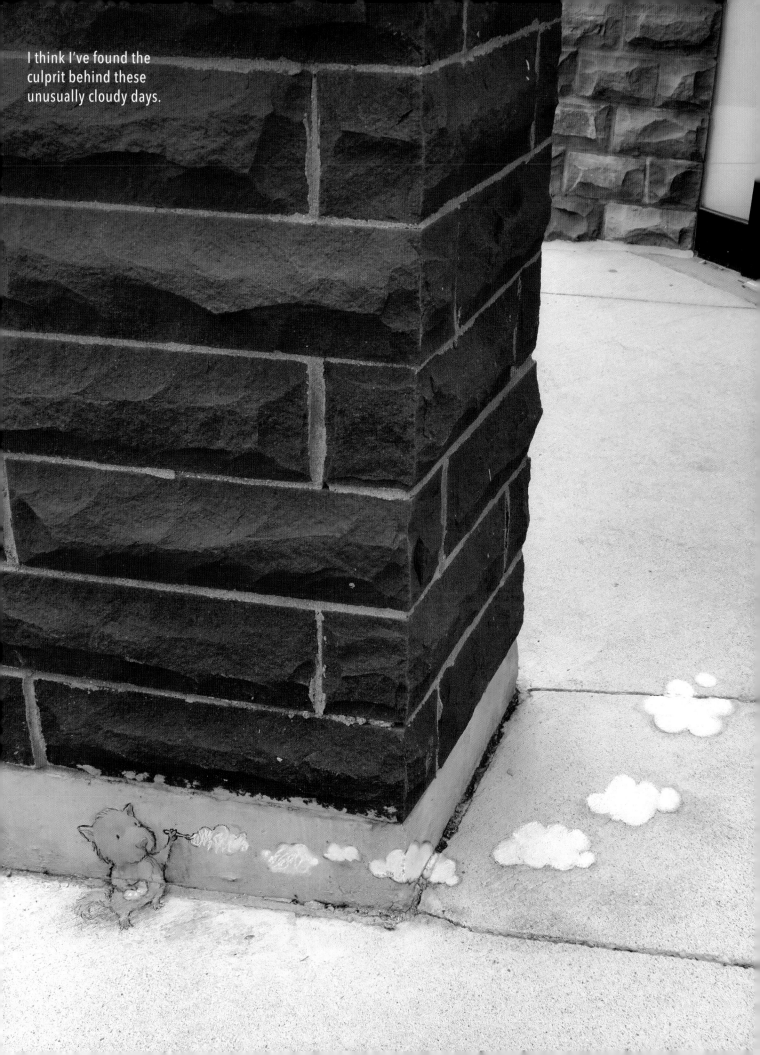

I think I've found the culprit behind these unusually cloudy days.

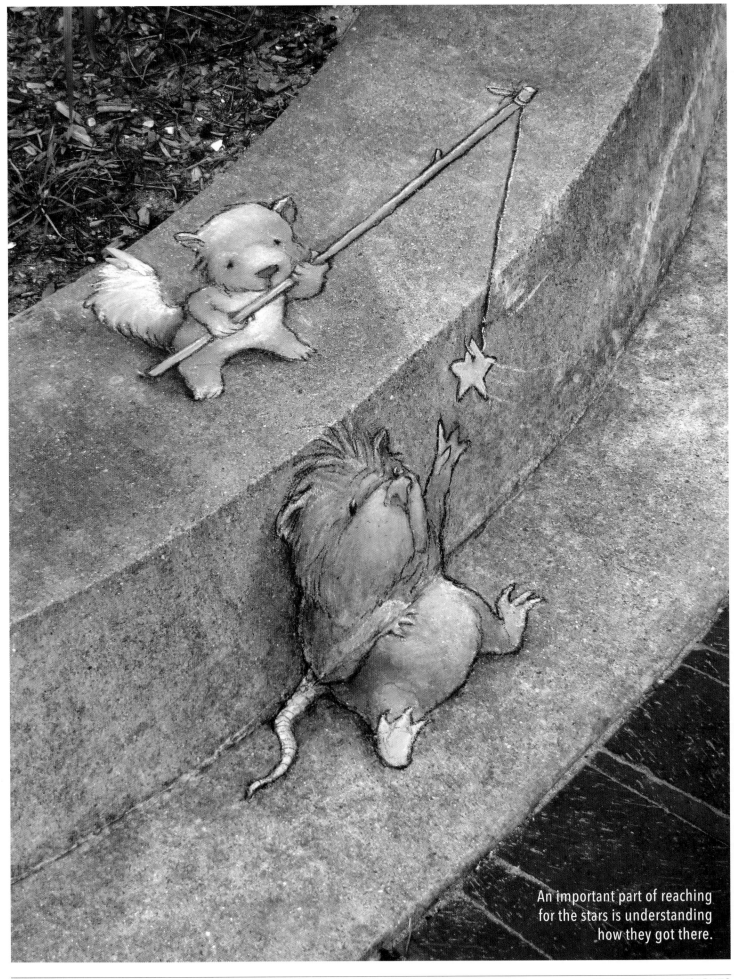

An important part of reaching
for the stars is understanding
how they got there.

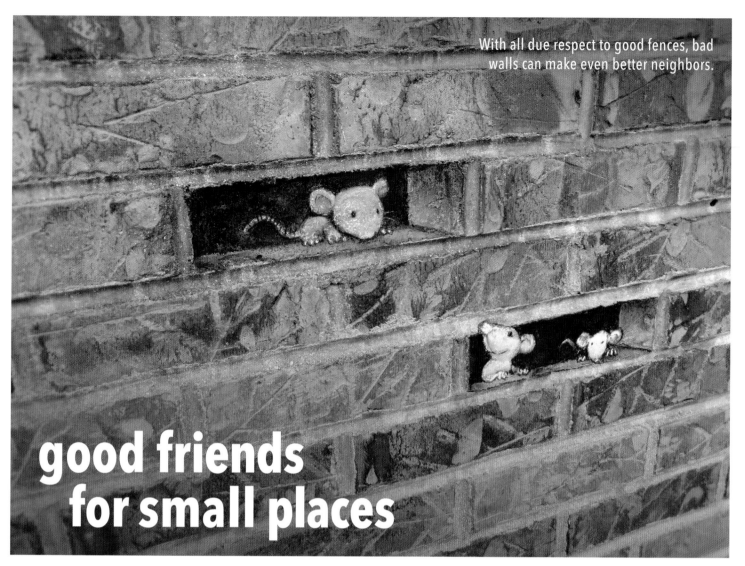

With all due respect to good fences, bad walls can make even better neighbors.

good friends
for small places

The first time I drew on a brick wall, I was waiting for a friend on a quiet street in Philadelphia, and gave in to the temptation of a perfectly smooth, tidily-framed drawing surface within easy reach. However, one tiny brick doesn't offer much space to draw in, so I only had room to show one eye peering out from the faux-darkness behind. I gave my installation the obnoxiously oblique title of "For the Love of God, Montresor," posted it online, and then got the greatest compliment of my artistic career when my own brother admitted he thought the eye had been drawn on a flat space behind an actual missing brick.

Later on, when I tried to include Sluggo in my other brick-based excursions, I found that his eyes were ill-suited for the job, given that they protrude awkwardly onto the surrounding mortar and lose much of their dewy charm when rendered on an extra-small scale. Thus the mice became my rescuers yet again: small, button-eyed, and typecast for the role of peeking out of gaps in walls.

This usefulness of mice in small spaces (and brief drawing opportunities) has resulted in a murine takeover of my portfolio; counting by individuals, I currently run into more mice than flying pigs, or even Sluggo – and this despite the fact that I don't really know how to draw mice. They start out OK at the nose end, but get progressively less micey on the way down. Luckily, I've determined that (as with pigs) people notice noses the most and stop paying attention soon after.

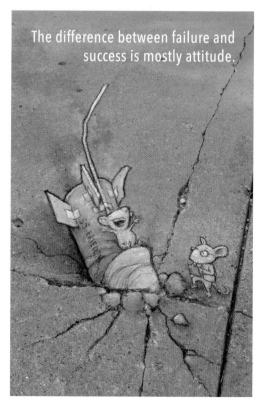

The difference between failure and success is mostly attitude.

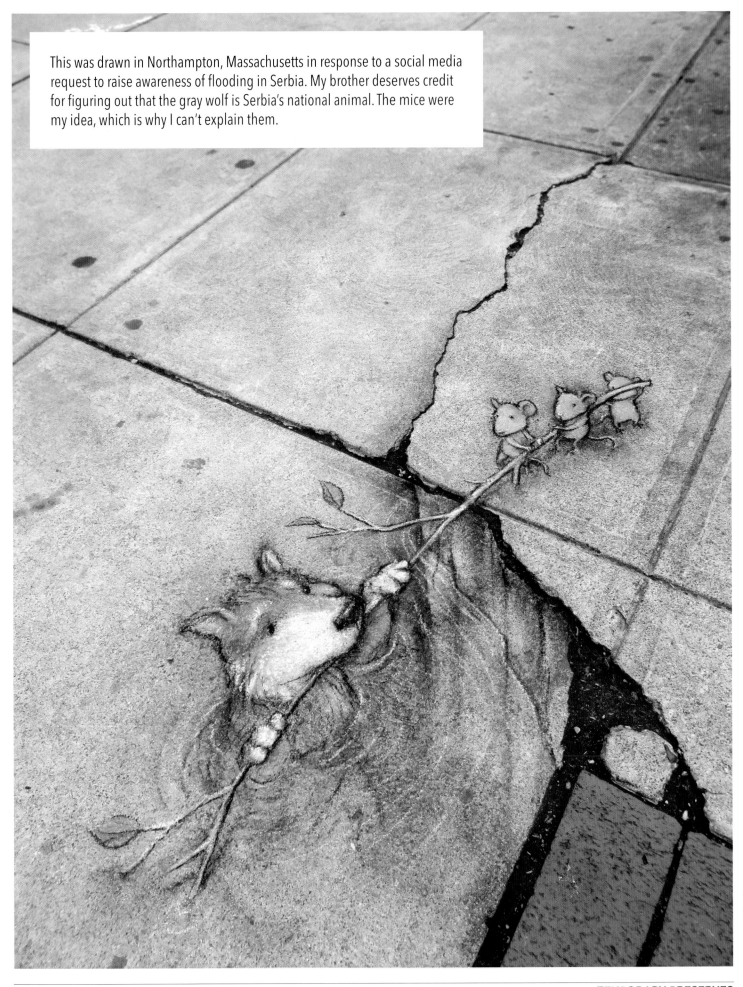

This was drawn in Northampton, Massachusetts in response to a social media request to raise awareness of flooding in Serbia. My brother deserves credit for figuring out that the gray wolf is Serbia's national animal. The mice were my idea, which is why I can't explain them.

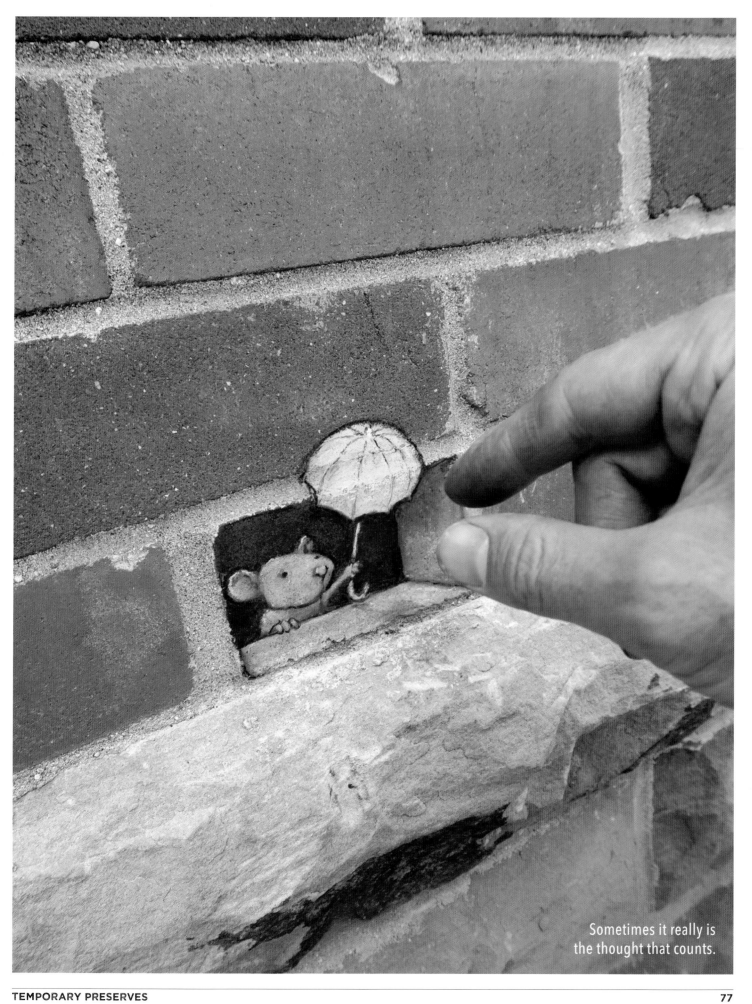

Sometimes it really is
the thought that counts.

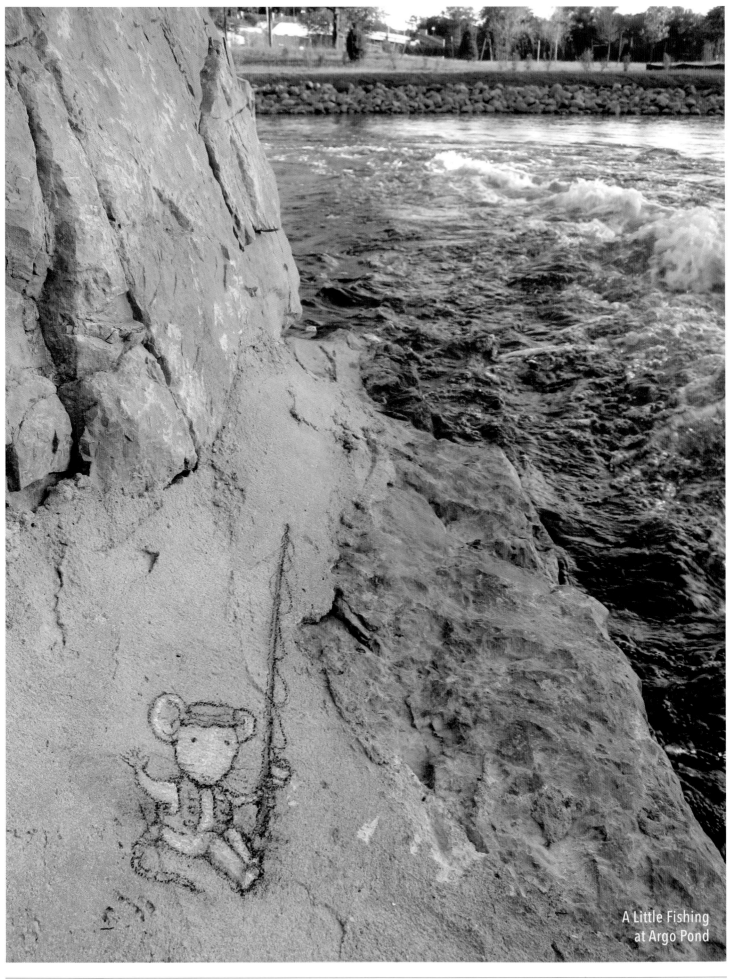

A Little Fishing
at Argo Pond

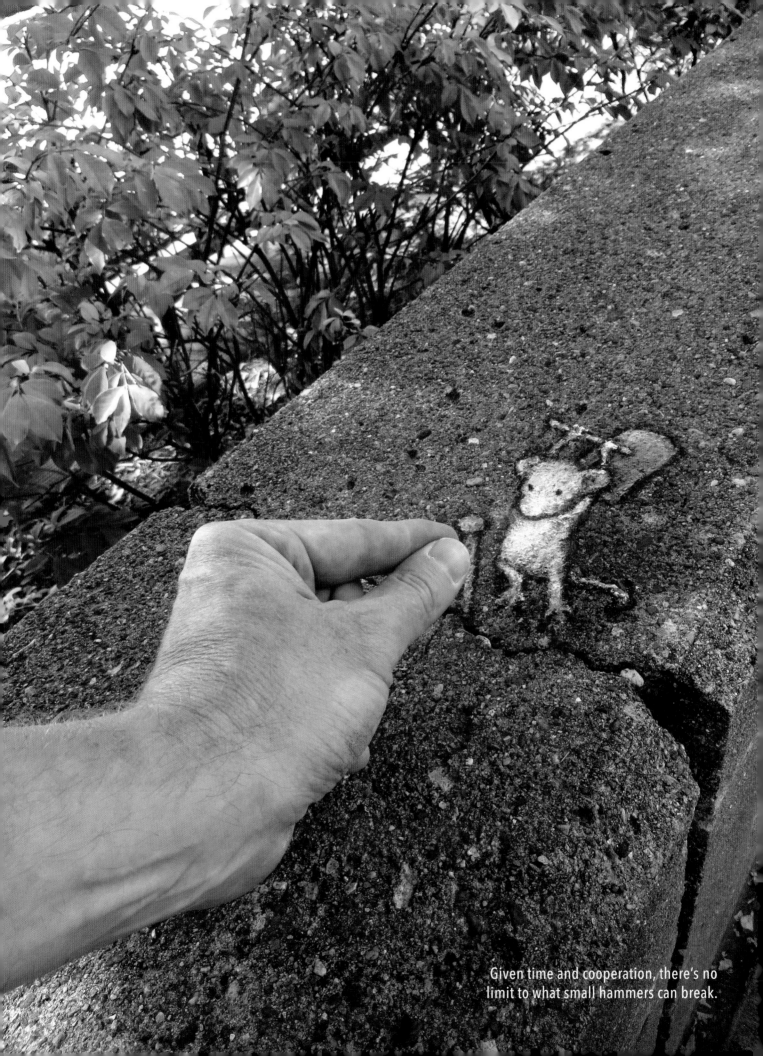

Given time and cooperation, there's no limit to what small hammers can break.

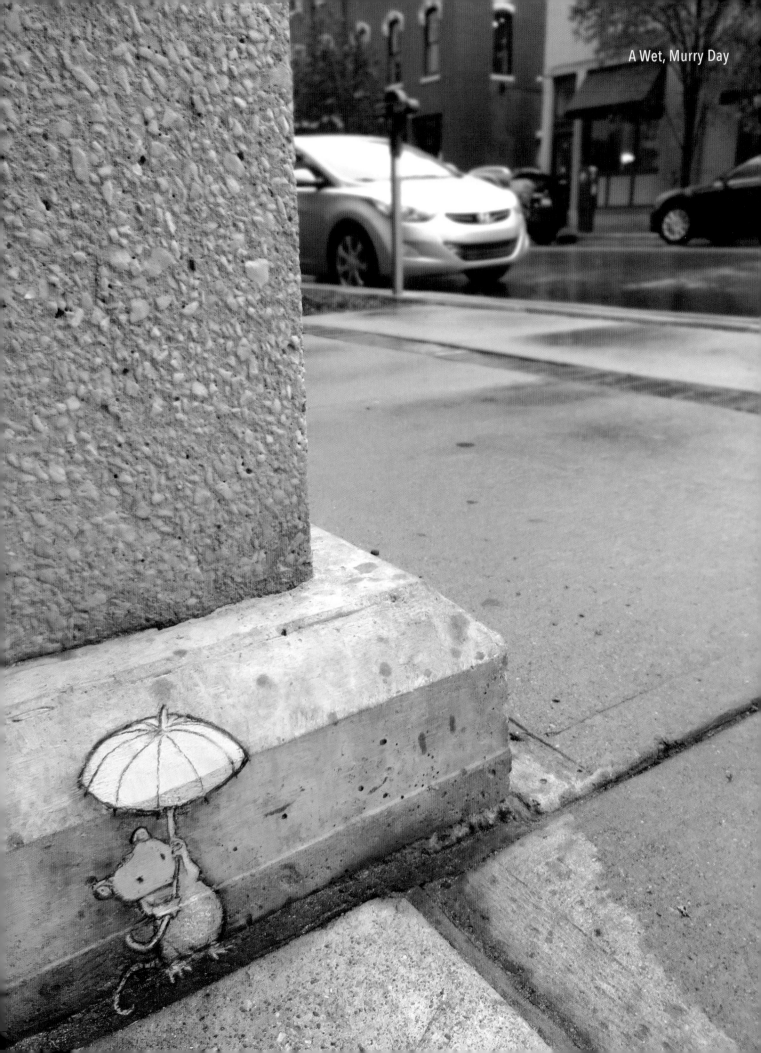

A Wet, Murry Day

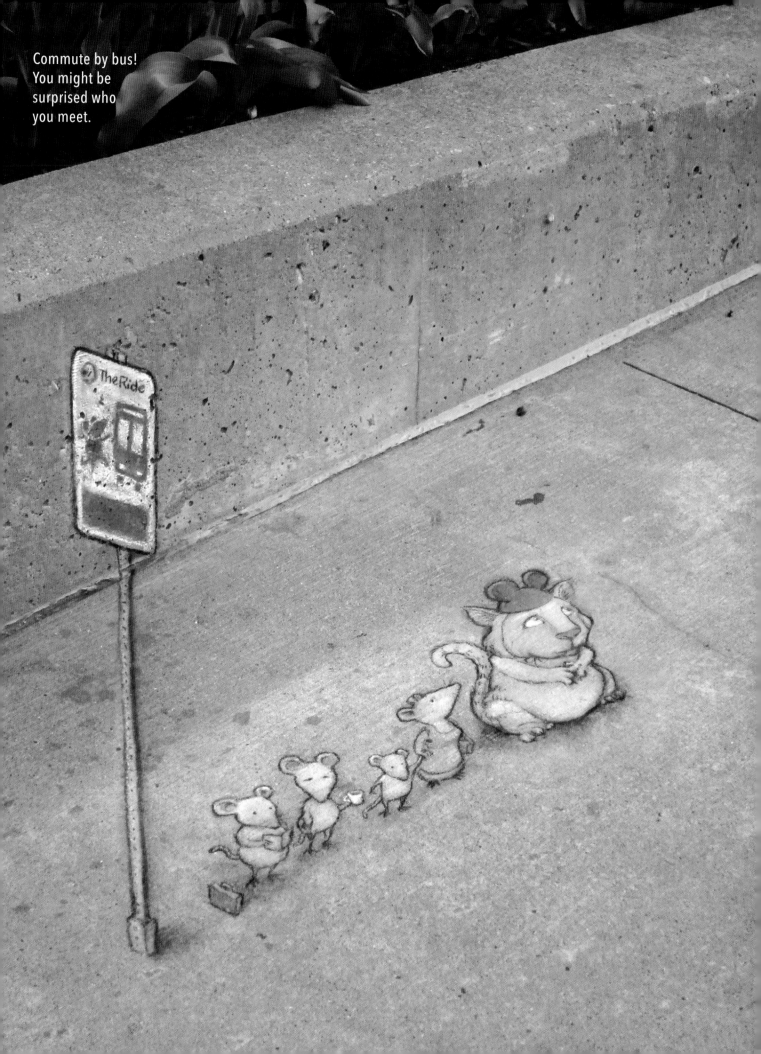

Commute by bus! You might be surprised who you meet.

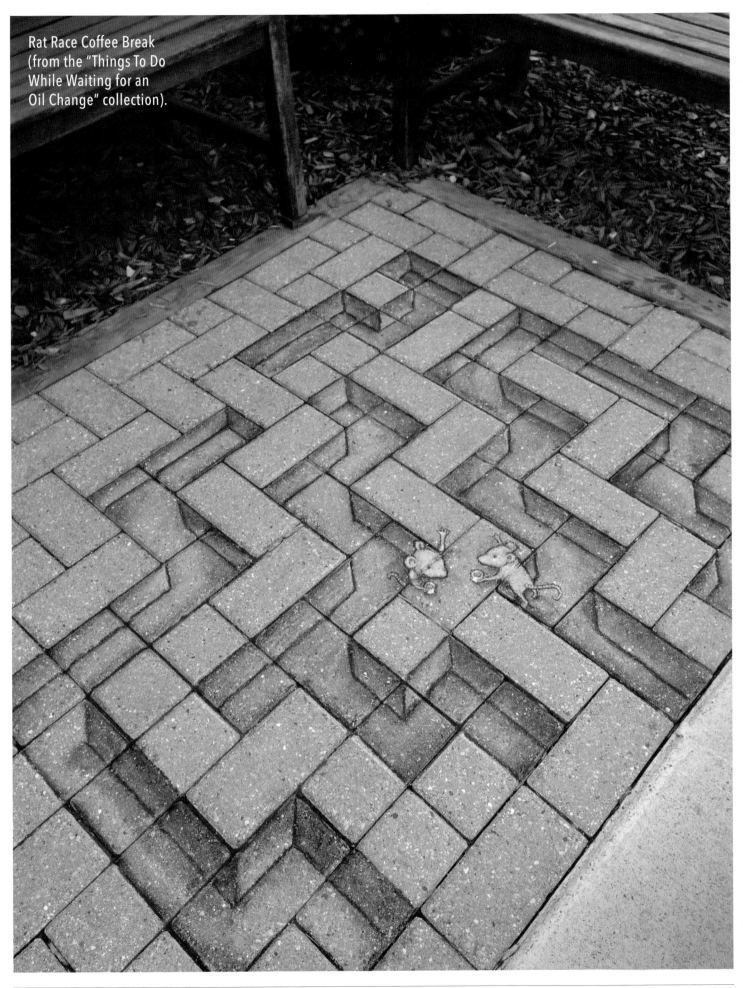

Rat Race Coffee Break (from the "Things To Do While Waiting for an Oil Change" collection).

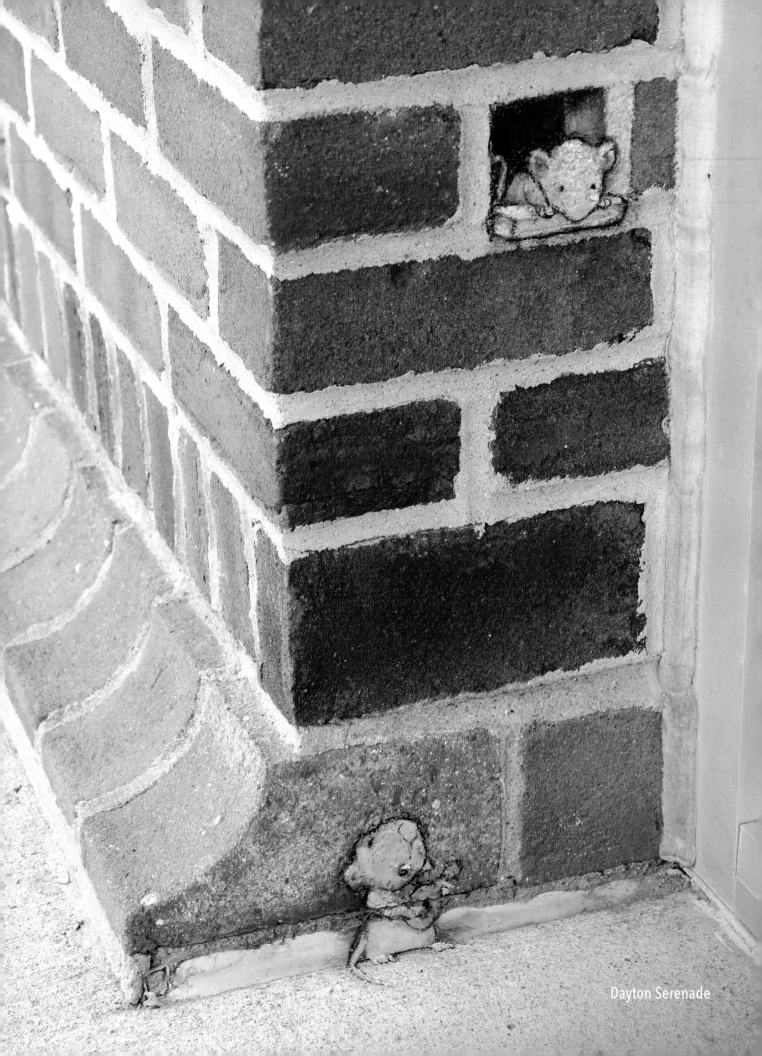

Dayton Serenade

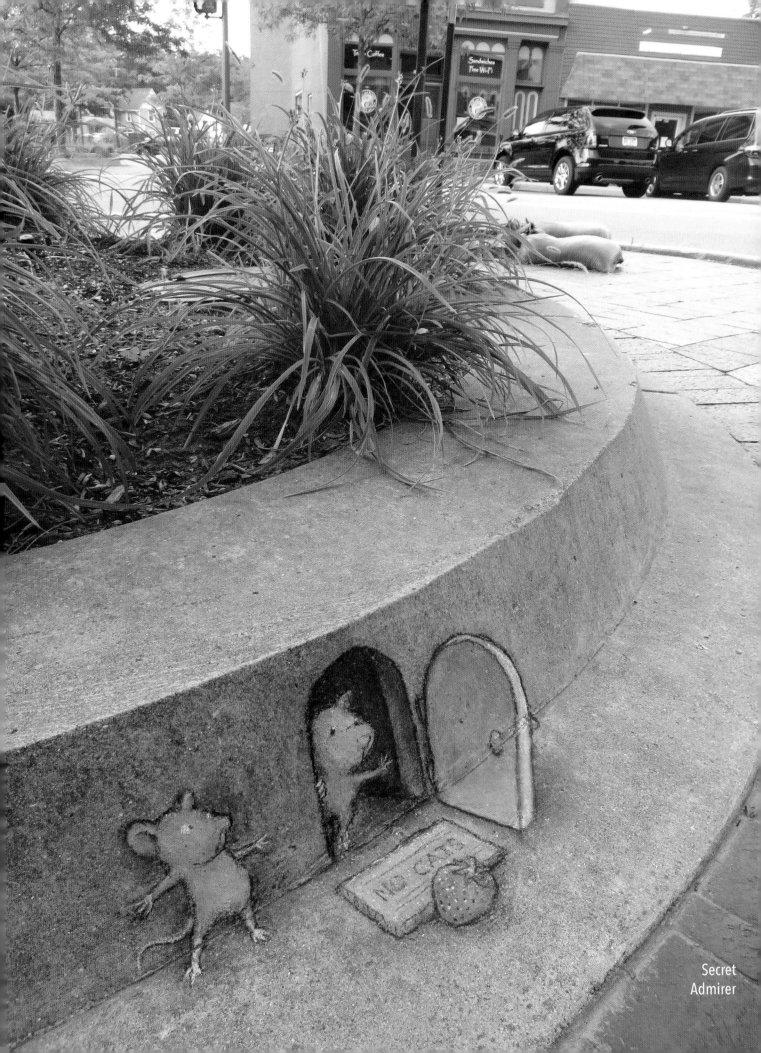

Secret
Admirer

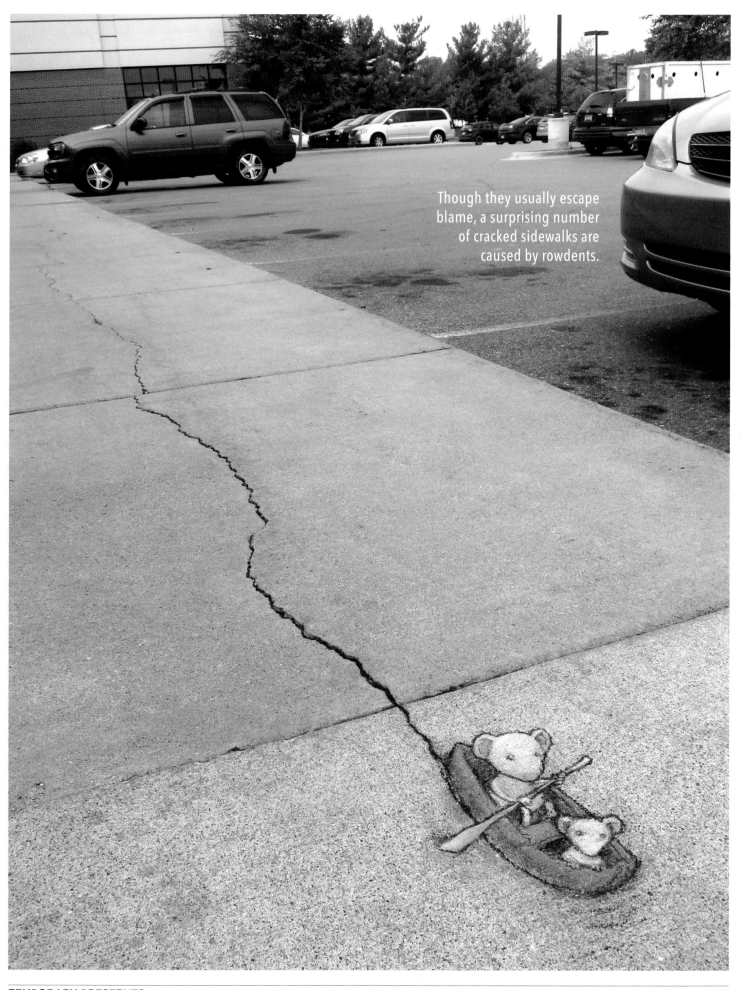

Though they usually escape blame, a surprising number of cracked sidewalks are caused by rowdents.

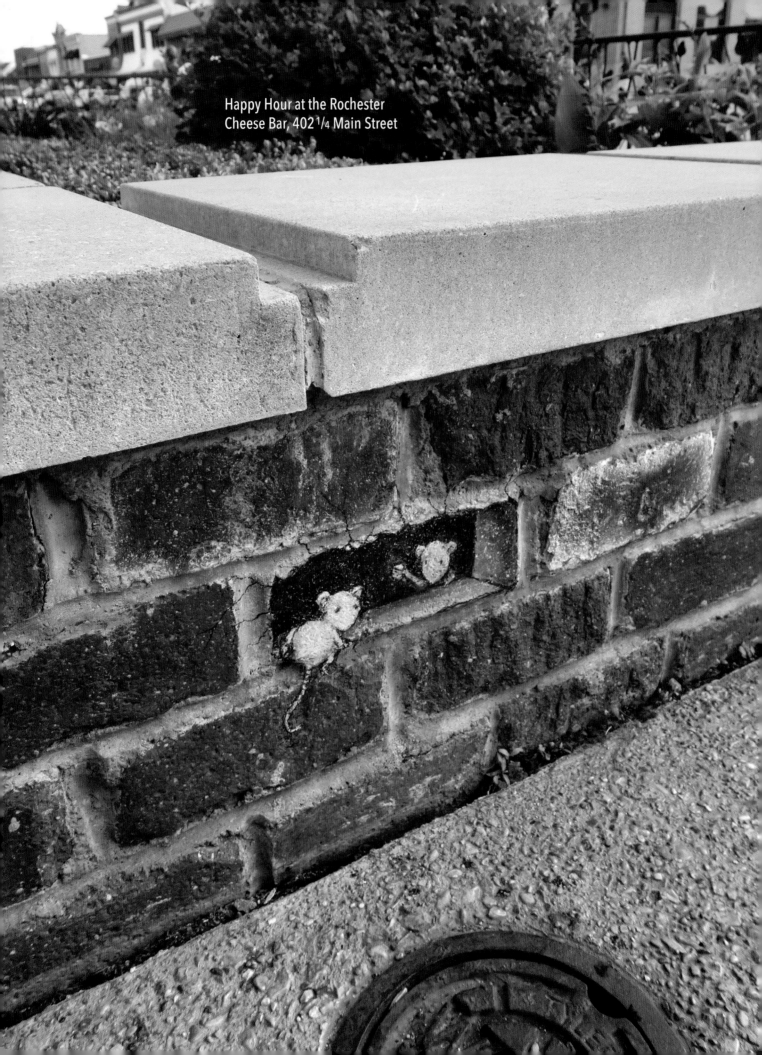

Happy Hour at the Rochester
Cheese Bar, 402 ¼ Main Street

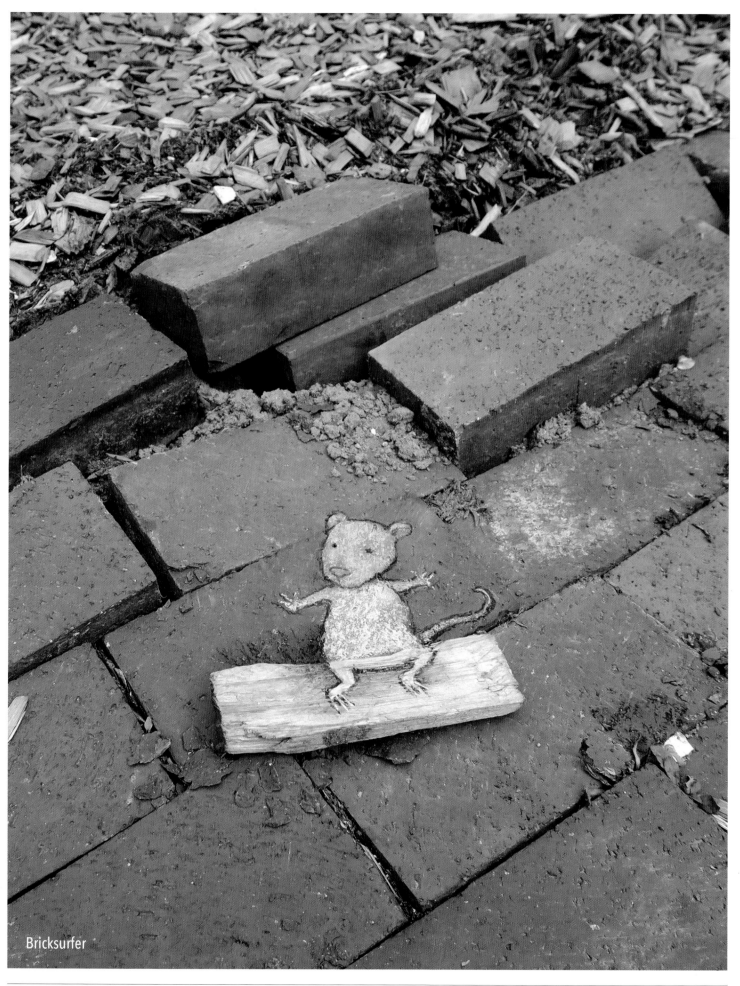

Bricksurfer

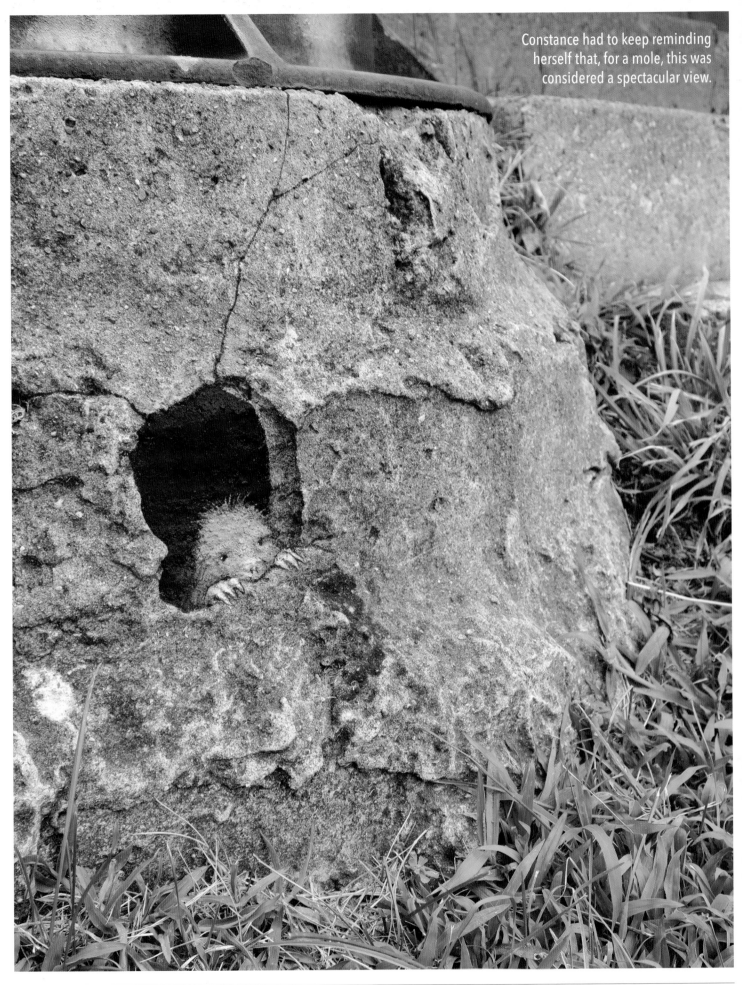

Constance had to keep reminding herself that, for a mole, this was considered a spectacular view.

TEMPORARY PRESERVES

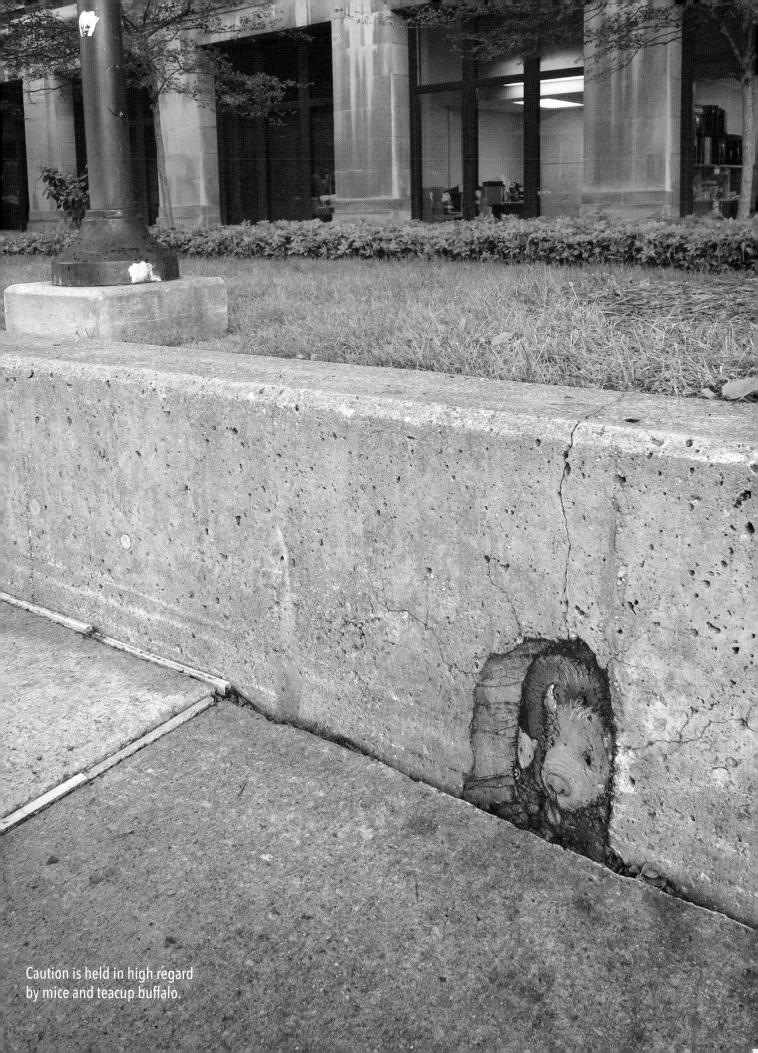

Caution is held in high regard
by mice and teacup buffalo.

the slug in winter

It could be argued that Michigan is a poor choice of habitat for an al fresco artist; the winters are cold, long, and snowy, and the summers seek balance through blazing damp heat. However, it was only because Ann Arbor so rarely lingers in the mild and breezy 70s that I was able to rationalize ignoring my indoor responsibilities to draw on the sidewalk in the first place. I believe that a mild, sunny day spent indoors guarantees an extra day of sleet in February, so if the skies are blue, my chalkbox comes out.

Unfortunately, I've underestimated two things. I've become so fond of my underfoot friends that I can't stand being parted from them from October to May, and my powers of rationalization have thus inevitably reached beyond "It's a nice day; I should go outside to draw" and into the territory of "It's a terrible day, but I bet I can prove it hasn't beaten me by going outside to draw anyway."

I won't argue that these cold-weather chalkings are as joyful and gratifying as the summertime ones; they are all limited by frozen fingers, salt-covered pavements and slushy pedestrian feet. Nonetheless, they put up a good fight in an unfriendly environment, and I hope that means they take people even more by surprise. A big part of surviving winter in Michigan is being open to surprises.

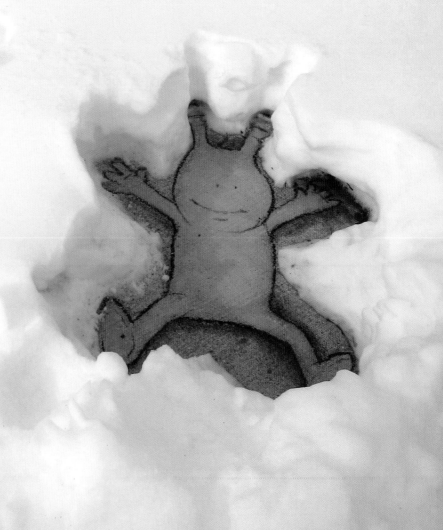

Sluggo attempts to prove sidewalk chalk's year-round compatibility with an elusive "slug angel."

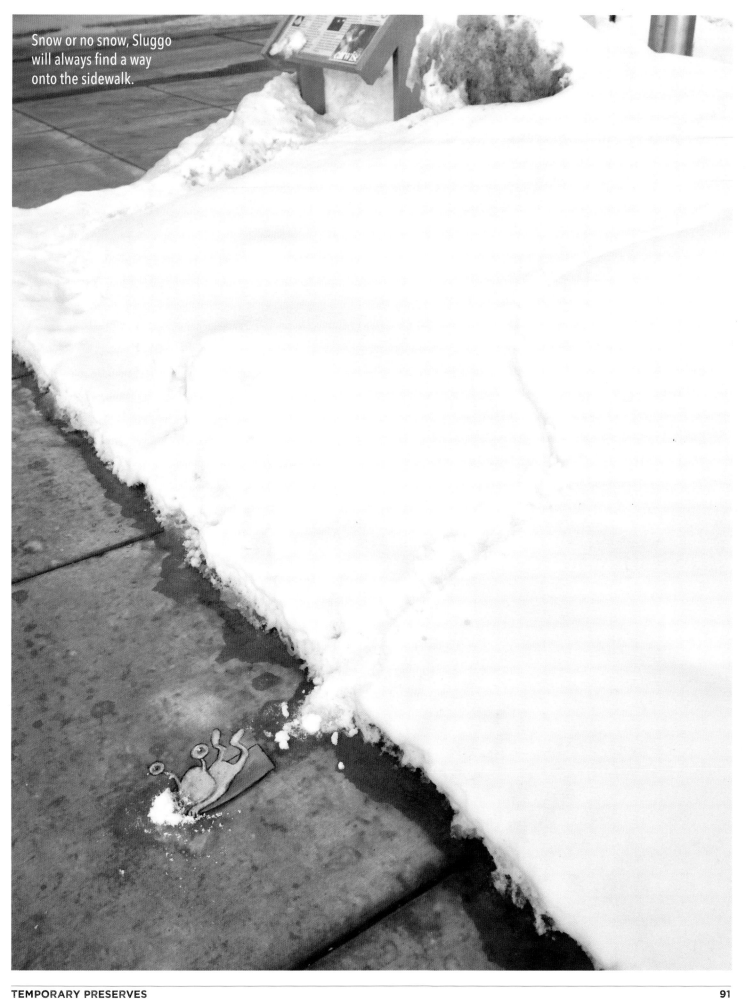

Snow or no snow, Sluggo
will always find a way
onto the sidewalk.

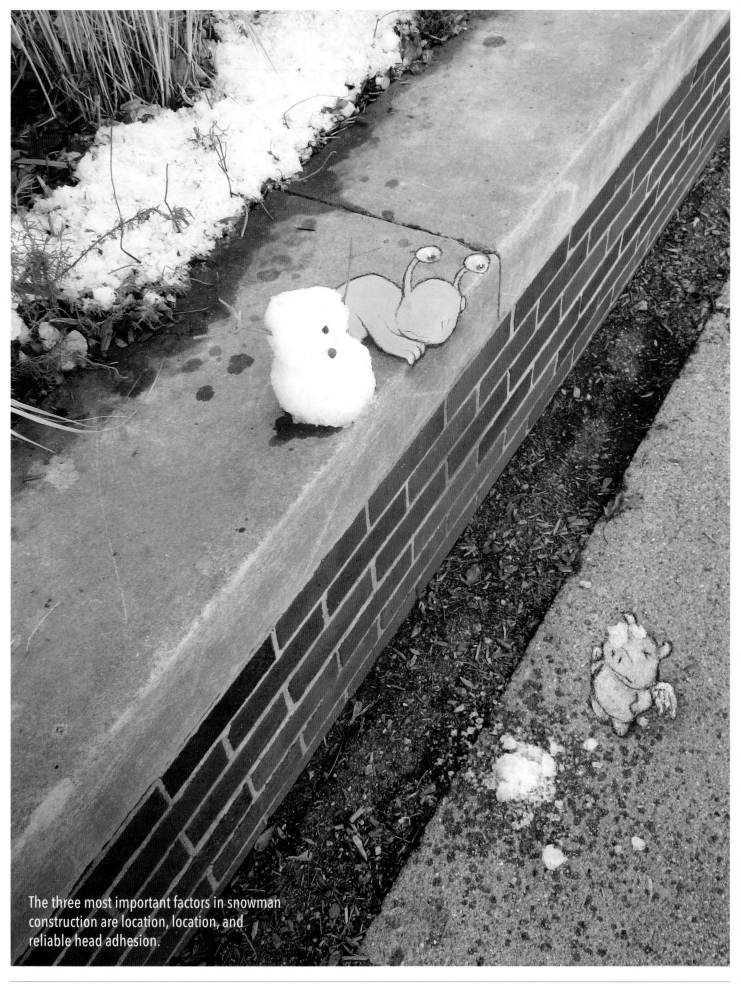

The three most important factors in snowman construction are location, location, and reliable head adhesion.

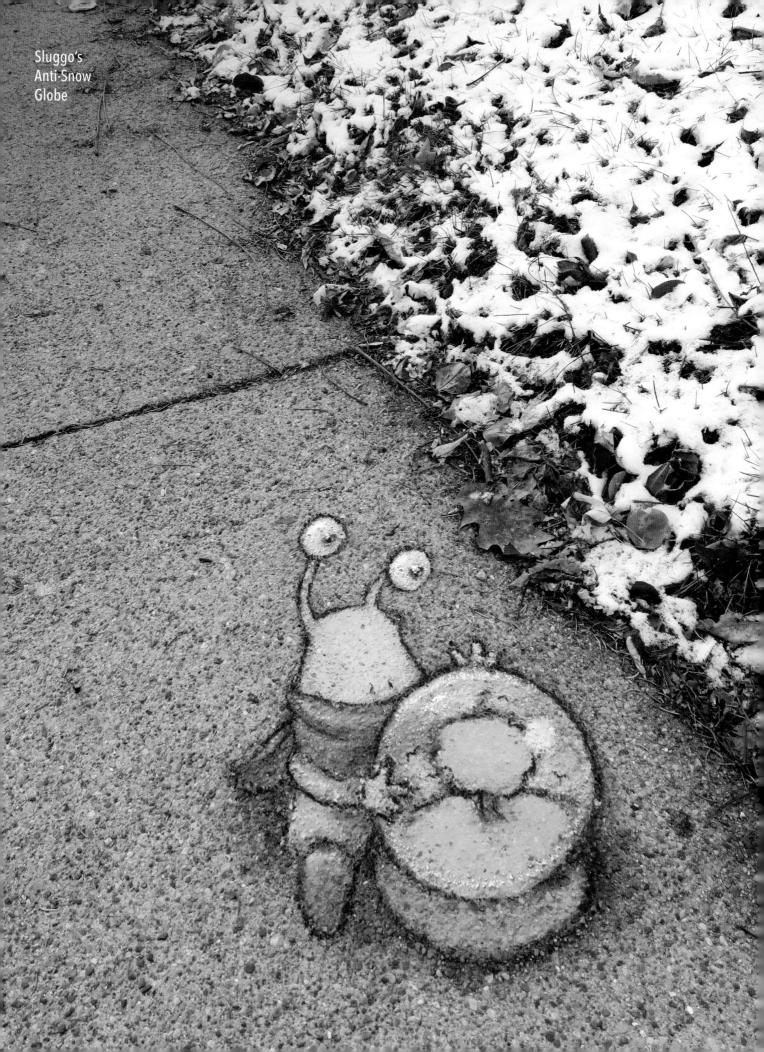

Sluggo's
Anti-Snow
Globe

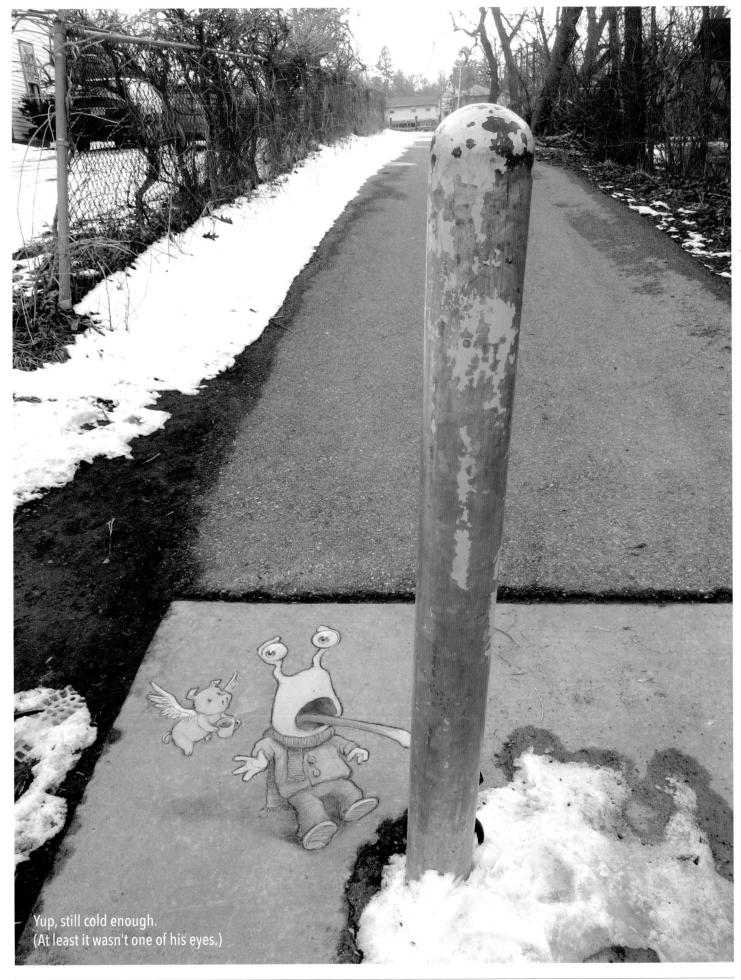

Yup, still cold enough.
(At least it wasn't one of his eyes.)

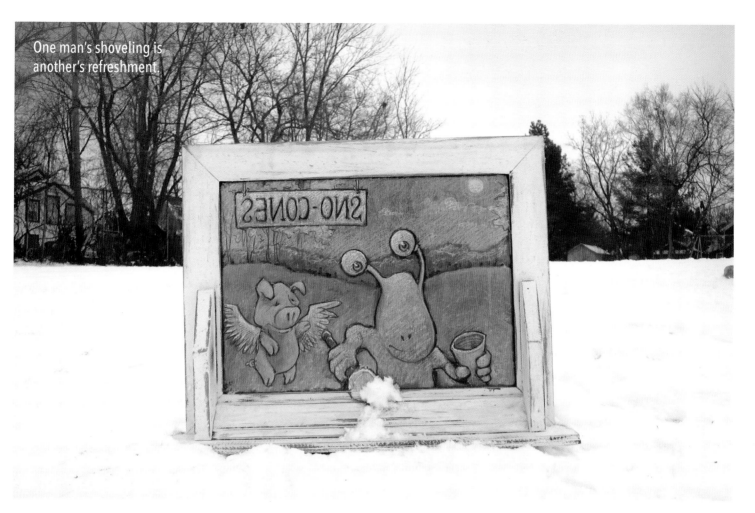

One man's shoveling is another's refreshment.

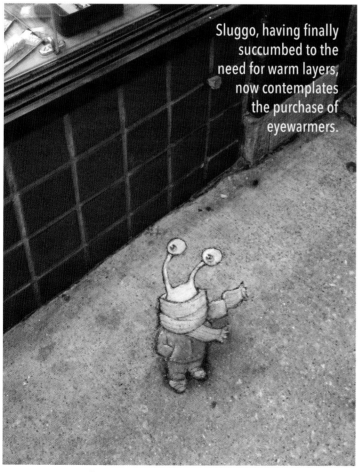

Sluggo, having finally succumbed to the need for warm layers, now contemplates the purchase of eyewarmers.

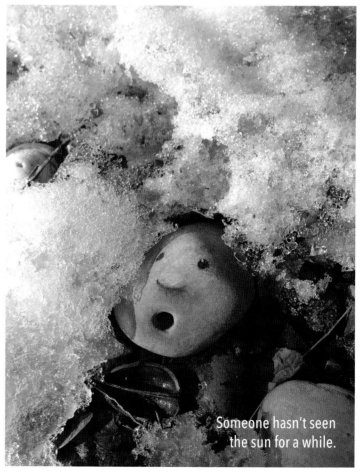

Someone hasn't seen the sun for a while.

TEMPORARY PRESERVES

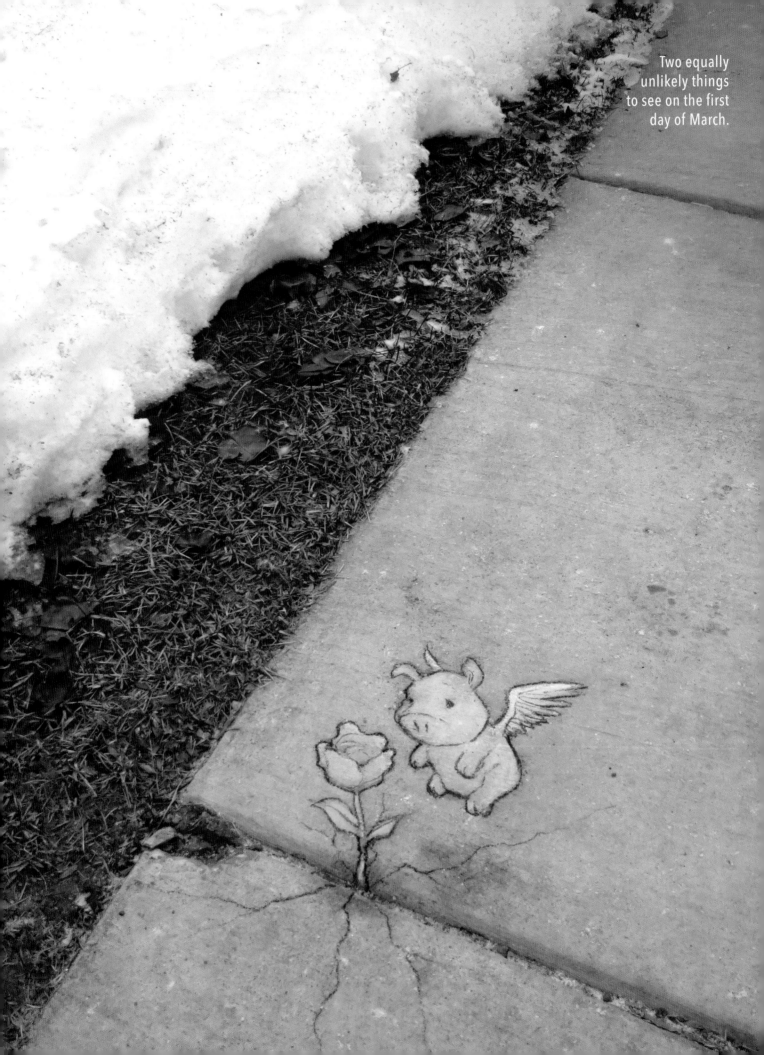

Two equally unlikely things to see on the first day of March.

drawn in while dining out

In praise of concrete bartops and tolerant bartenders

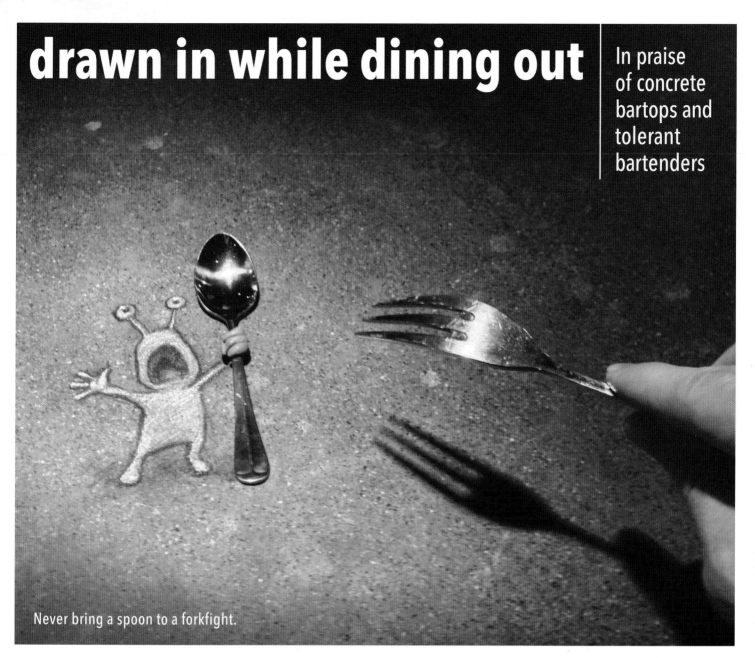

Never bring a spoon to a forkfight.

Whether it's due to deep snow, heavy rain, or thick holiday crowds, there will always be days when drawing on the sidewalk is out of the question. Luckily, life is full of indoor doodling opportunities: paper placemats, coasters, bar napkins . . . for the man willing to travel with a piece of chalk behind his ear, the whole world is a canvas.

It should be noted that public indoor chalk art requires the indulgence of the establishment involved, since the role of Mother Nature in removing the artwork is replaced by a bartender with a rag. I've been lucky to find safe harbor in many places, and should give special thanks here to Café Zola for letting me use their concrete bartop as a creative Rorschach test, and the Blue Tractor BBQ & Brewery for printing their logo on only one side of their coasters.

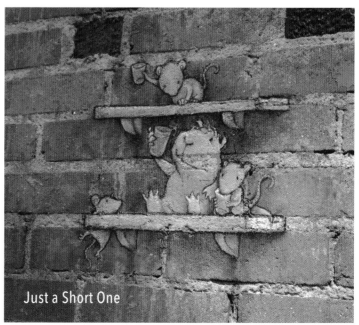

Just a Short One

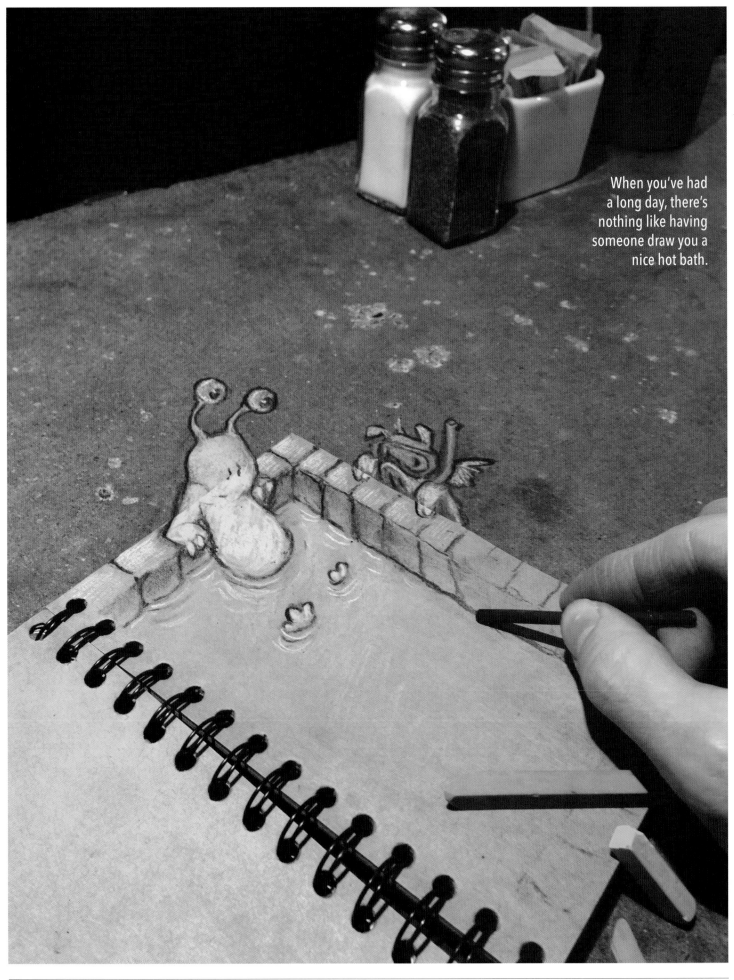

When you've had a long day, there's nothing like having someone draw you a nice hot bath.

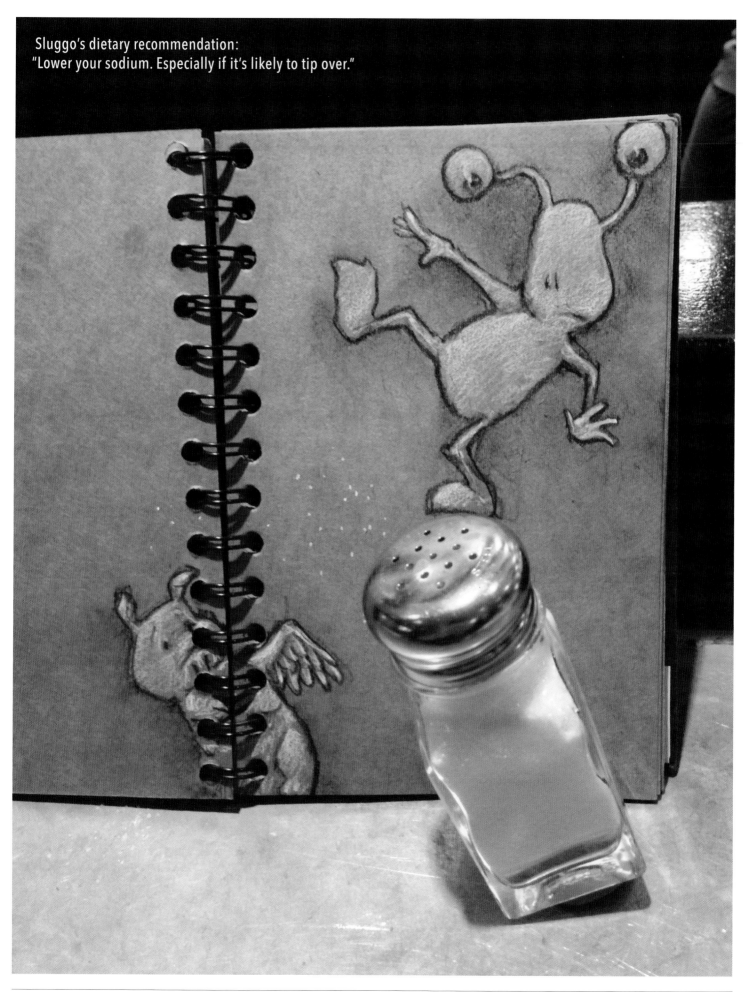

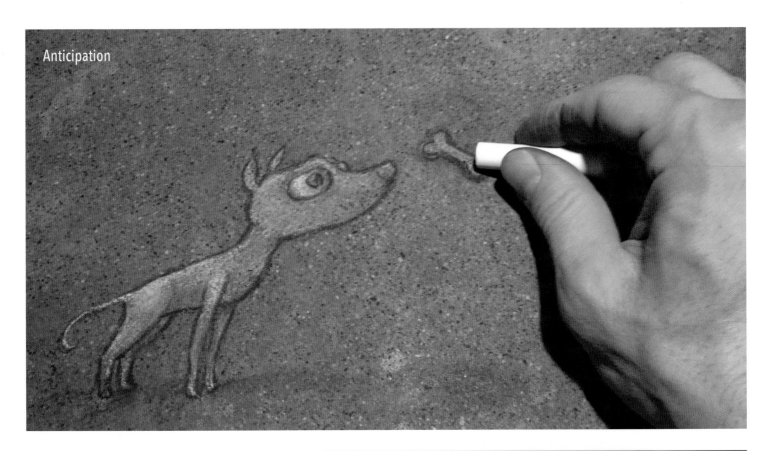
Anticipation

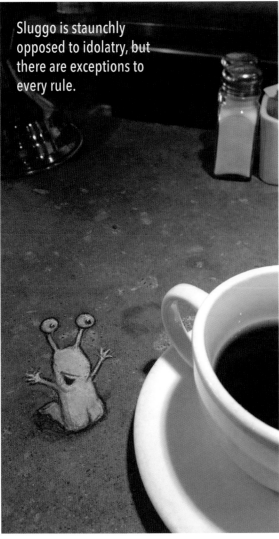
Sluggo is staunchly opposed to idolatry, but there are exceptions to every rule.

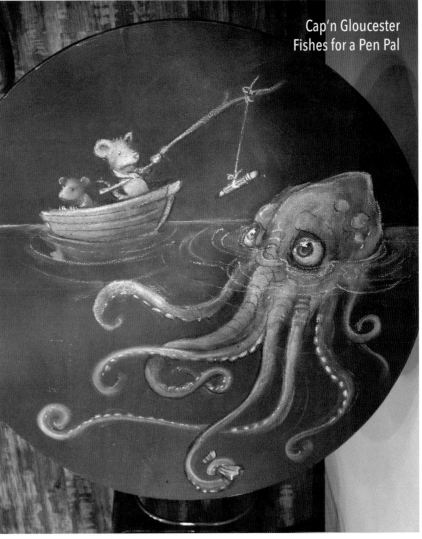
Cap'n Gloucester Fishes for a Pen Pal

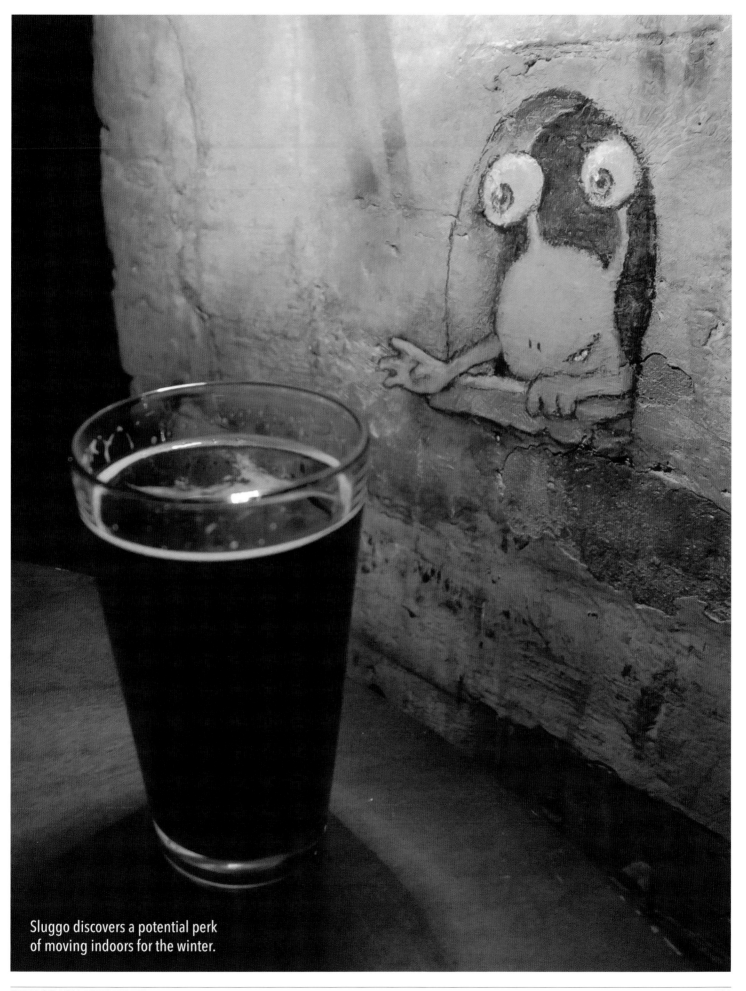

Sluggo discovers a potential perk of moving indoors for the winter.

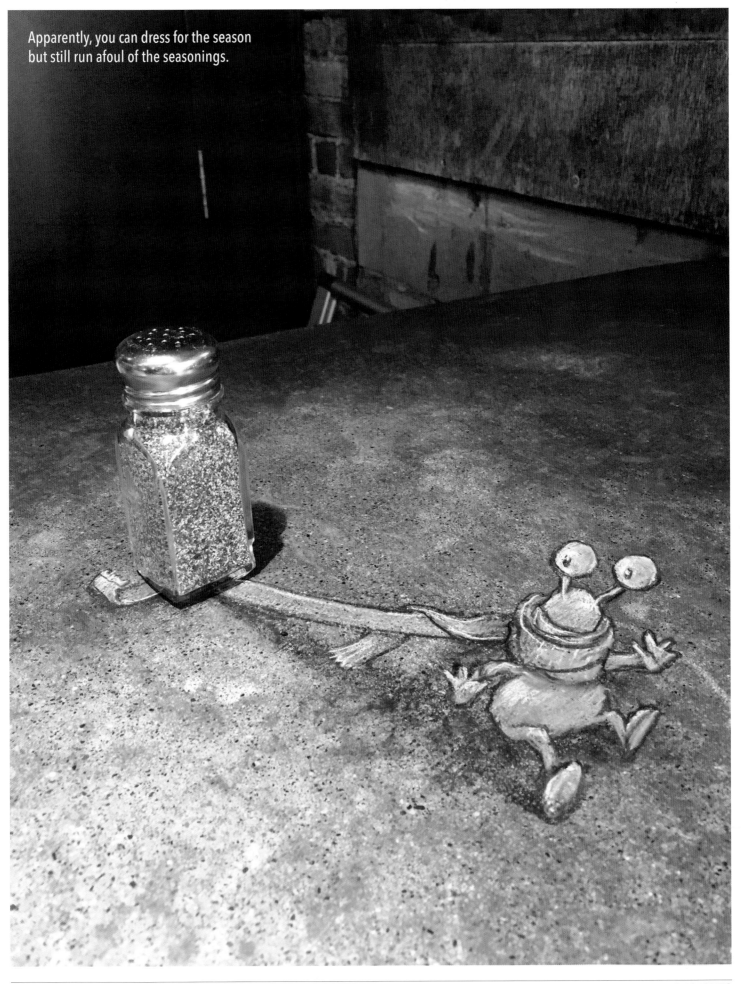

Apparently, you can dress for the season but still run afoul of the seasonings.

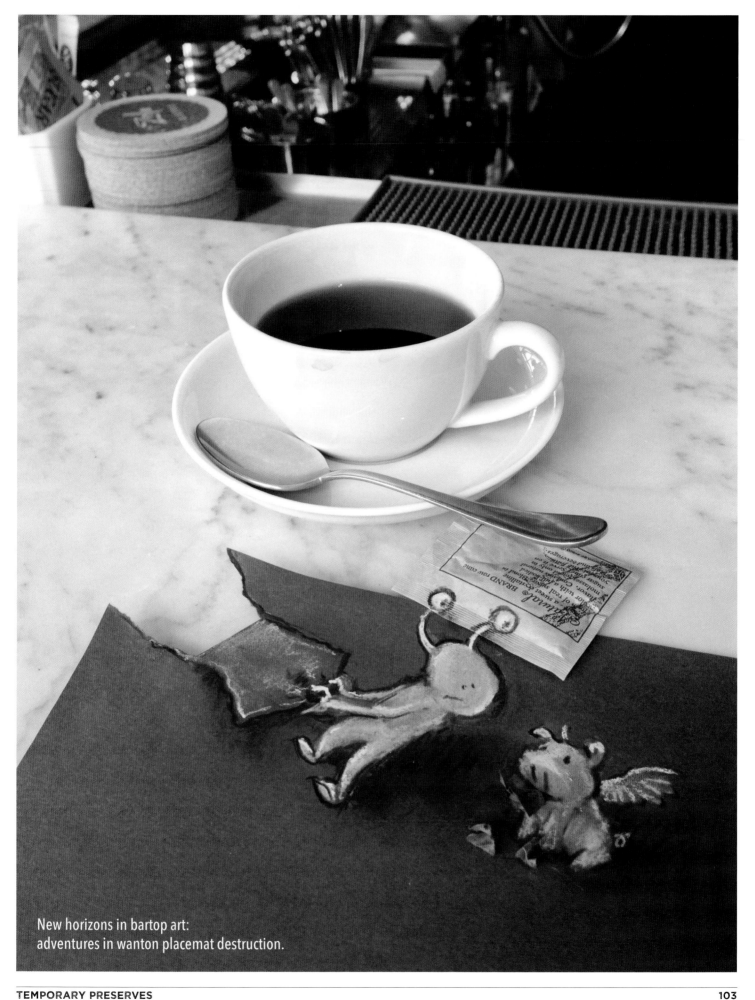

New horizons in bartop art:
adventures in wanton placemat destruction.

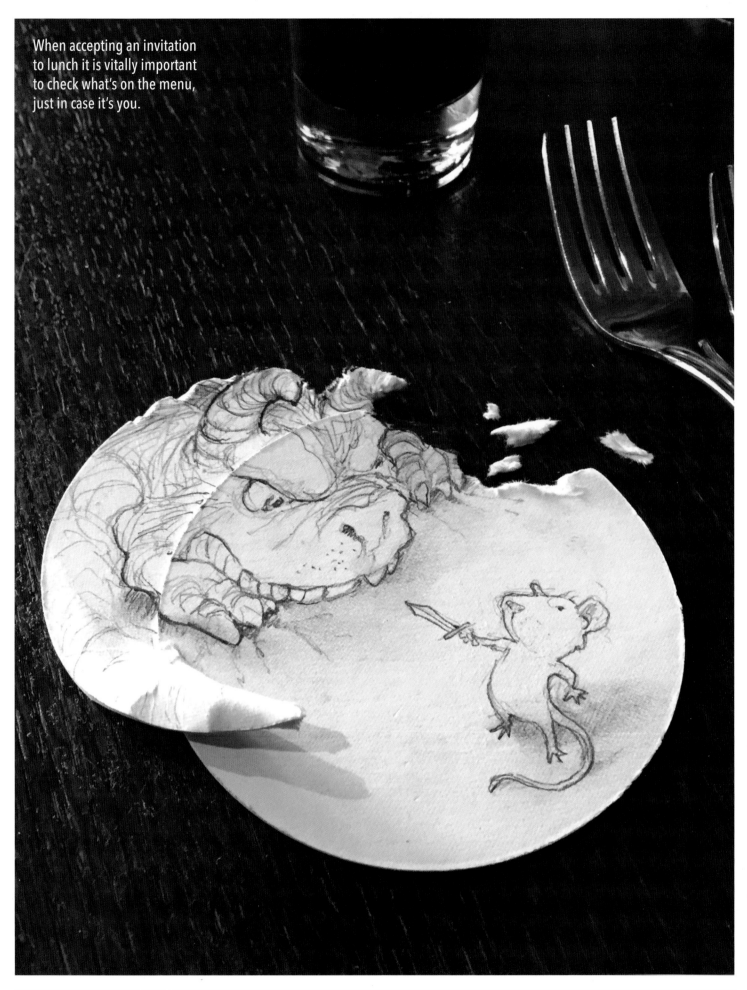

When accepting an invitation
to lunch it is vitally important
to check what's on the menu,
just in case it's you.

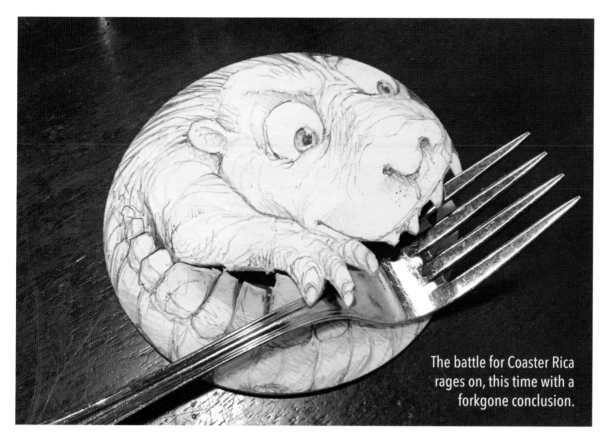

The battle for Coaster Rica rages on, this time with a forkgone conclusion.

Technically, these three images do not belong in this book, because they were created with pen and pencil (and cutlery) instead of chalk. However, if you want to recreate the spontaneous joy of temporary street art indoors without risking the wrath of the proprietor and also killing time waiting for a hamburger, you could do worse than doodling on the back of a coaster.

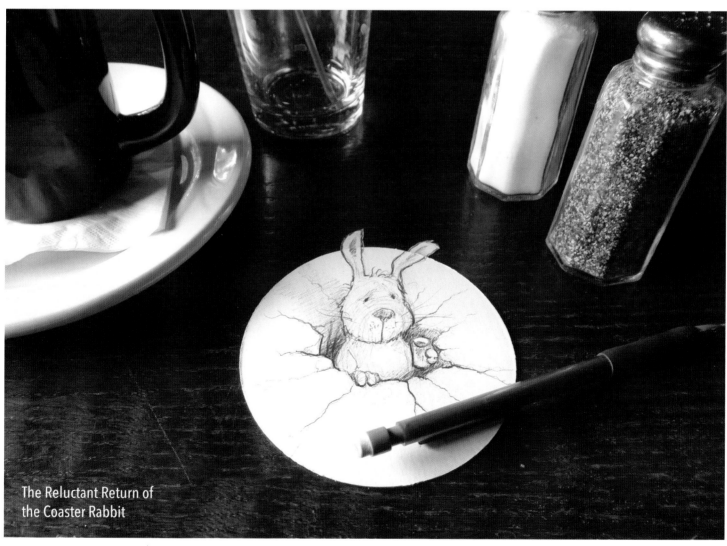

The Reluctant Return of the Coaster Rabbit

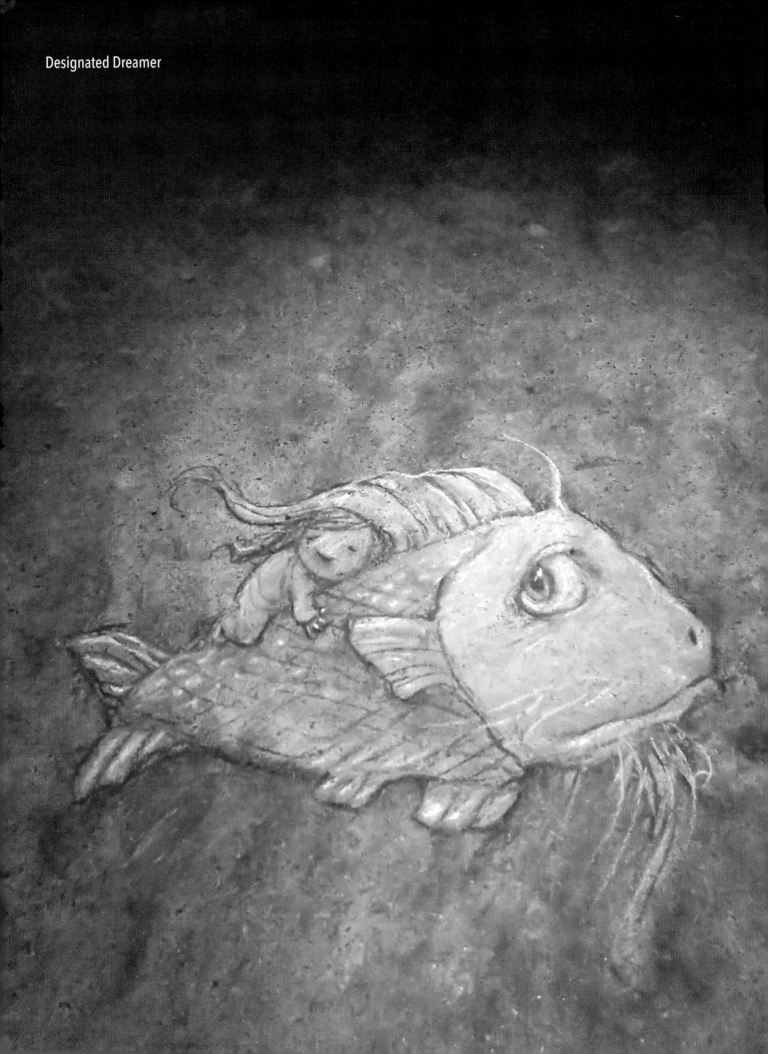

Designated Dreamer

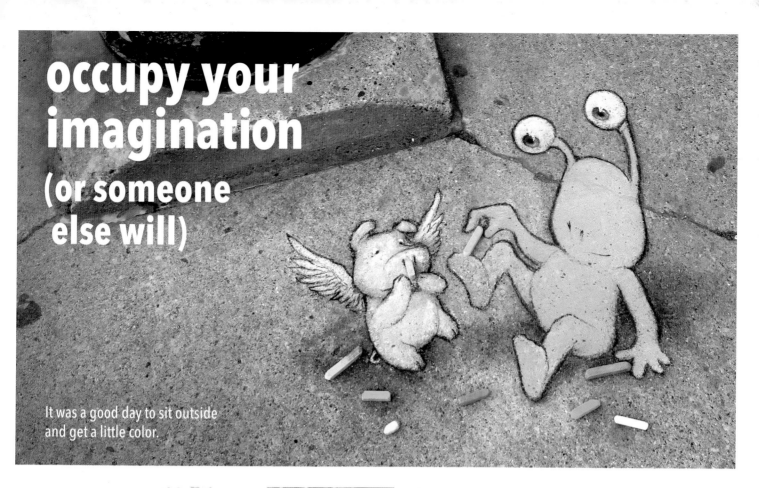

occupy your imagination
(or someone else will)

It was a good day to sit outside and get a little color.

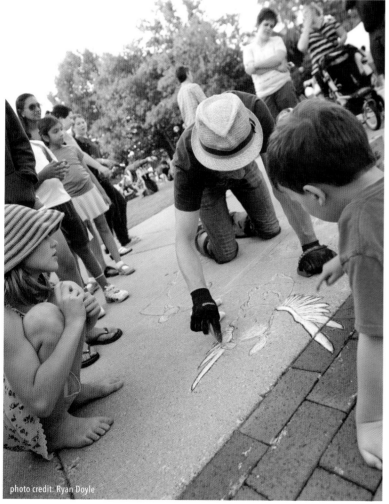

photo credit: Ryan Doyle

The most common question I hear while drawing on the sidewalk is "won't you be sad when it rains?" In case you've been wondering the same thing, I'll answer that here: No. On the contrary, it's the temporary nature of chalk art that makes it so liberating and so recommendable as an artistic outlet. After years of trying to produce "important," purpose-driven commercial art, my first sidewalk drawing was ridiculous, anonymous, and quickly destroyed by rain – all perfect circumstances for uninhibited creativity.

The less confident you are of your drawing skills, the more strongly I recommend you try drawing with chalk. You say you can only draw stick figures? No problem. Stick figures are in the upper half of the skill curve for sidewalk art. Just want to scribble in circles until the chalk is worn down to dust for the sheer joy of making a mess? You will be far from the first person to spend a happy afternoon doing that.

This is not to suggest that everyone needs to embrace drawing as a means of expression. I recommend it as an activity you can do almost anywhere with almost anything, but the same can be said of making music or telling stories, and some people clearly get the same satisfaction out of telling a good joke as I do out of making a pebble look like a bug. Whatever it is that you enjoy doing in a way that feeds your soul and seems to serve no other practical purpose, you should probably be doing more of that.

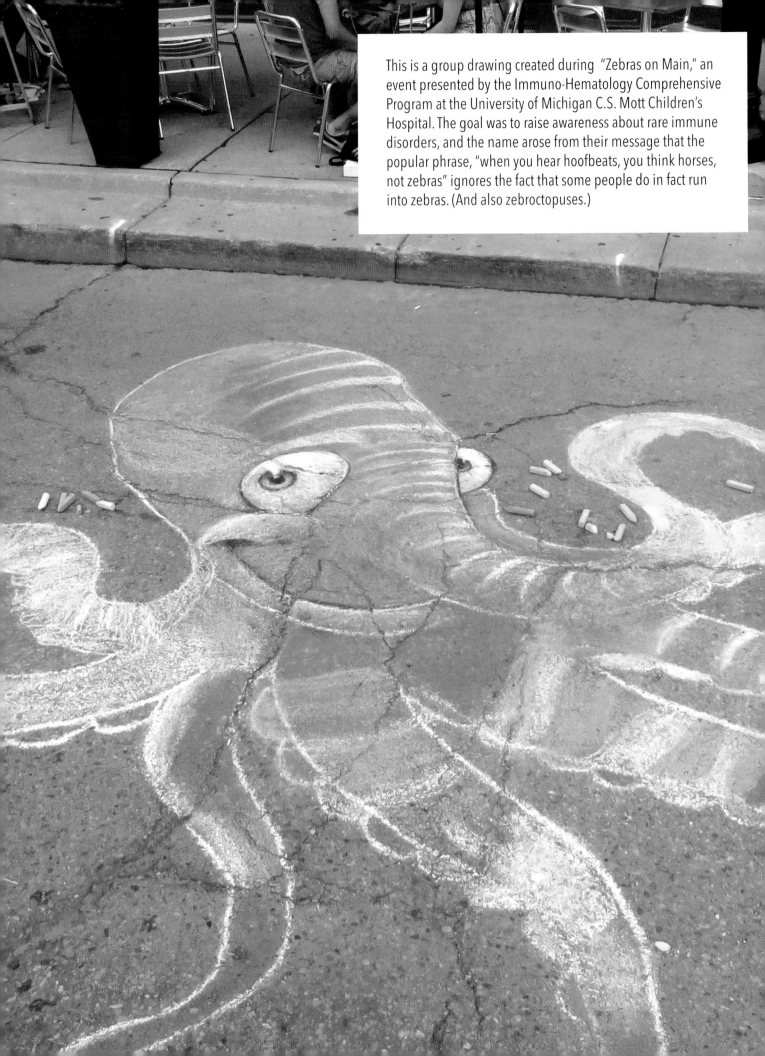

This is a group drawing created during "Zebras on Main," an event presented by the Immuno-Hematology Comprehensive Program at the University of Michigan C.S. Mott Children's Hospital. The goal was to raise awareness about rare immune disorders, and the name arose from their message that the popular phrase, "when you hear hoofbeats, you think horses, not zebras" ignores the fact that some people do in fact run into zebras. (And also zebroctopuses.)

about the artist

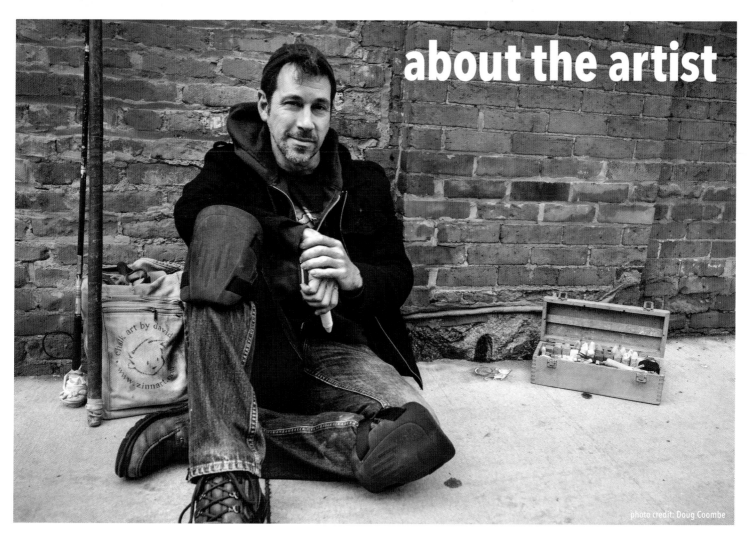

photo credit: Doug Coombe

David Zinn has been working as a freelance artist since the age of twelve and drawing on sidewalks since 2001. His temporary street art installations are viewed by thousands of people on social media every day and have been featured on *msnNOW, Yahoo, The Huffington Post UK, Colossal, The Guardian, Upworthy, Street Art Utopia, Reddit, Dorkly, Imgur, La Boite Verte, Topolino, Graffiti Art Magazine,* Central China Television, and Instagram's own Instagram page. Mr. Zinn's previous book, *Lost and Unfounded,* sold out its entire print run in nine months, leaving strong hopes that a spare copy is hidden under a railway bench somewhere in Kiev.

With this wide-ranging audience, David hopes to break the misconception that art can only be found inside frames and on pedestals, and that being an artist requires seriousness and dignity. Using simple tools in public spaces, he hopes to help others feel more comfortable with embracing their own creative potential. In the meantime, he's grateful to have a good excuse to play outside on a nice day.

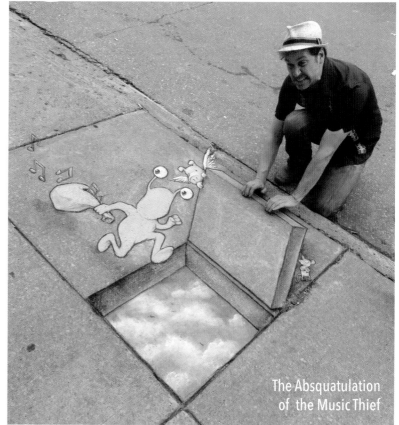

The Absquatulation of the Music Thief

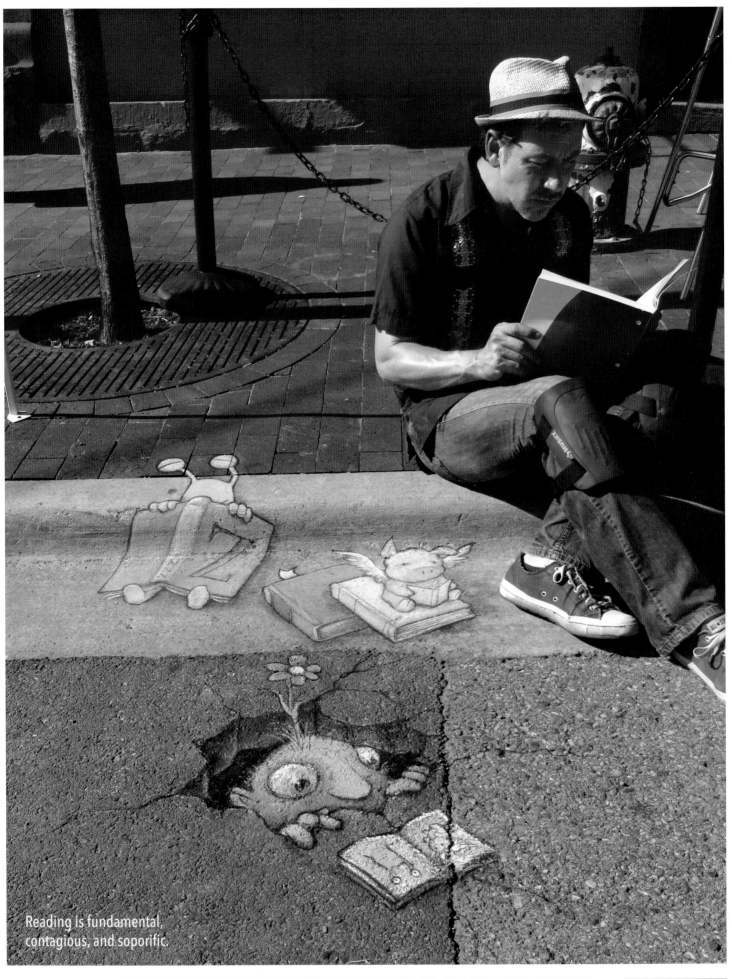

Reading is fundamental,
contagious, and soporific.

Our Benefactors: This book exists only because of the generosity of the more than 500 people (mostly listed on this page plus eighty who wished to remain anonymous) who contributed to the "Temporary but Preserved" Indiegogo campaign in 2015. These excellent people stepped up to such a degree that the campaign has been allowed to shift into "InDemand" status for the foreseeable future, which means it now raises funds for the donation of this book and chalk art workshops to schools, libraries and community centers. You can see the campaign for yourself at igg.me/at/davidzinn.

Abbie Innes
Abhinav Dasari
Adam Carr
Aditi Muralidharan
Alan Wineman
Alesia Glidewell
Alexandra Neumann
Alexis Jeandet
Alicia Addessi
Alicia F Williams
Allegra Kirmani
Allison H Kinney
Ambereen Pathan
Amy C Skypala
Amy Faith Martin
Amy J Austin
Amy Lee
Amy Sammartino
Amy Sundback
Amy W Cook
Ana Riehlmann
Andrea Sooyoung Yun
Andrea Trimmer
Andrew McDonald
Andrew Port
Angela Compri
Aniko Laczko
Anita Y Whang
Anja Geist
Ankur Singal
Ann E Hendricks
Ann & Karl Zinn
Anne Farrand
Annemiek Hamelink
Anthony R Stengel
Antoine Imhoff
Antonio D Gonzalez
April D Pickrel
Audrey Rasmusson
Austin N Chrzanowski
B A Cancaro
Barbara A Dinneweth
Barbara J. Kirby
Barbara M Lamar
Becky Reese
Beth Bongiorno
Bev Leroux
Bianka von Kulajta
Bill Futoransky
Bing She
Birgit Bischof
Birute Z Gillis
Bonnie L Schmick
Bradley Alan Katz
Brandi M Hensley
Brandy L Simula
Brenda Milstead-Reese
Brennan M MacDonald
Brian Williams
Brian Woodruff
Bruce Graham
Bryan Berend
Bryant Wu
C.A.V.E. Gallery

Carla Schuermann
Carol A Kielty
Carol A Munsell
Carol L Micheletti
Carol M Fast
Carol Schlatter
Carolyn B Maruggi
Carolyn Rubin
Carrie L Christoph
Carsten Scheinpflug
Carter M Zinn
Catherine Becker
Catherine J Buck
Catherine Johnson
Catherine M Zinn
Catherine S McDowell
Cathy Mercer
Cheryl A Sutherland
Cheryl Williams
Christa Bellock
Christina Liu
Christophe Wozniak
Cindy Dauer
Cindy Kelly
Circe Powell
Clive Green
Constance J Cales
Cora Diamond
Craig Robertson
Cristine Letourneau
Cynthia Ives
D J Schiphorst
Dalila M Sanchez
Dan Untenzu
Daniela D'Arcangelo
Daniel D Madaj
Daniel Tietze
Daria
Darlene P Nichols
David Dunleavy
David Goldberg
David New
David Pickell
Dawn Nulf
Debbie Ogden
Debra Brow
Debra S Fierro
Deni Drinkwater
Denise L Henhoeffer
Denise Tanguay
Diane Sembler Kamins
Dianne T Pawluk
Didi Yep
Dika E Ryan
Dirk Schiphorst
Doina Niculescu
Donald E Theyken Jr
Donna Constant
Donna Plocinski
Donna Washburn
Edward Kozuto
Elena Muravieva
Elaine Polishak
Eliane Snels

Elisa Larrea
Elisabeth N Latner
Elizabeth F Pheasant
Elizabeth J McNamara
Elizabeth Jahn
Elizabeth Lobos
Elizabeth R Crisher
Elizabeth Spiegel
Emma Fox
Erica L Katz
Eric Blad
Erin Darrigan
Ernest Vicencio
Esmeralda Pang
Esther Green
Eva Hoesel
Evan R Padgitt
Faith Navarre
Frank D Zinn
Frank K Zinn
Frederic Farrand
Gary Wickboldt
Geoffrey S Allen
Georgina Titmus
Gerard Tokar
Gerrit Jan Hoogeland
Gianfranco Berardi
Glenda J Bullock
Gretchen Redding
Guido Ciampi
Hannah Bader
Harry Benford
Heather Lord
Heather Wurster
Hedieh Briggs
Helen Nero
Helena Brunnerová
Helena F Dunan
Holly Gaut
Husna Azad
Ingrid Forzley
Irith Wiegand
Isabella Weber
Ivanell R George
Ivaylo Cherkezov
J Dempsey
Jackie Waldman
Jaie Tomkinson
James Boydston
Jan Berry
Jana Jamieson
Jane Blumenthal
Janet Chong
Janis Ann Bobrin
Jannina Norpoth
Jason Sennitt
Jean Henry
Jeanne Marioni
Jeff Banet
Jeff Spindler
Jeffrey Herzka
Jenitta Virissimo
Jennifer Chou
Jennifer Davis

Jennifer Dempsey
Jennifer Henkle
Jennifer L Arnold
Jennifer Langham
Jennifer Starrett
Jennifer Zinn
Jessica A Kaplan
Jessica Litman
Jim Beiting
Joan E Leigh
Joan S Martin
Joanne Carscadden
Jocelyn Baldwin
Joey Leftow
John C Ardussi
John Quinn
Jonathan L Van Noord
Jose Antonio Ramos
Joseph J Charney
Joseph M Menacker
Joseph Thomas
Joshua S Schwartz
Joy A Jagiello
Juan M. Ramirez
Judd Winick
Judith A Knox
Judith W Hamilton
Judith Walton
Judy O'Toole
Julia A Horodynski
Julia L Greenway
Julie Austen
Julie Weatherbee
Karen B Farris
Karen Dubois
Karen M Staller
Karen Osgood
Karen S Tipton
Karen Strickler
Karina Kangas
Karla Blackwood
Kat Nolan
Kate Kehoe
Katherine Broker
Katherine L Carnahan
Katherine Lawrence
Kathie Easom
Kathleen Laux
Kathleen Matheson
Kathryn ONeill
Kathryn Y Benford
Kathy Fessler
Katrina McDonnell
Katrina Novikova
Kay Schleusner
Keith A Sauers
Kelly M West
Kenichiro Obana
Karen Dubois
Karen M Staller
Karen S Tipton
Kerri Puckhaber
Kilian Rault
Kim Neal

Kim Sandin
Kirsten Louden-Bell
Koay Jie Ling
Kris Bryant
Laura Bell
Laura Lewarski
Laura Selleck
Lauren Works
Laurie Carpenter
Laura Pellegrini
Leah Dummich
Leigh Billings
Lenke Kiss
Lesley Craggs
Leslie Larkins
Lettie Broughton
Linda Diane Feldt
Linda Kothera
Linda Roehl
Linda Verhun
Lindsay M Clark
Lisa C Young
Lise A Rode
Liv Anne Andreassen
Liza Atreya
Lo Wing Ka Sally
Lori J Hammer
Lori Lewarski
Lorna Davalos
Lorraine Schwinn
Luis Escareno
Lucy Macdonald
Lynn M Lubben
Lynne Frederickson
Madeline S Miller
Madelynn E Allwein
Mak Shuk Han
Marcelle Humphreys
Margaret A Larrea
Margaret D Petersen
Margaret Rood
Maria Immaculata Arifin
Maria Simon
Marianne Cantor
Marie-Anne de Marcovitch
Marie Retherford
Marilyn Koster
Martha Curtis
Martha Fessler Krieg
Martin J Strauss
Martin W Hollander
Marvin C Bishop
Mary E Cain
Mary Larson
Mary Zinn-Beiting
Mateo Jones
Matthew Naud
Maureen Rombach
Megan Rodgers
Melanie Eckenfels
Melanie See
Melissa A Smith
Michael C Garrison
Michael Delugg

Michael Kennedy
Michael L Brantley
Michael McBride
Michael Zentner
Michele Sliger
Michelle Miller
Michelle Trame Lanzi
Misty McFarland
Monica Kircheis
Monica Tsuneishi
Monique R Sluymers
Murali Rathinasamy
Mya Gosling
Myra Klarman
N W Oatley
Nancy A Gebicke
Nancy Garber
Nancy L Tuttle
Naomi Ono
Natalia Goldman
Natalie Vuckovic
Natasha Cue
Nico Meijer
Nieka Apell
Nikki Mortimer
Noemi Mira-Bautista
Olena Ingerova
Pamela E Corbett
Pamela Shehan
Pam Langdon
Pat Wendt
Patricia Henhoeffer
Patricia L Pomykal
Patricia Ryan
Patricia Smith
Patrick Um
Paul & Jennifer Underwood
Paula Malozowski
Penny L Bartnicki
Peter Meisel
Peter Zinn
Philippe Joubrel
Philippe Mayor
Rachel May
Rachel Newman
Raj Jeyapaul
Randi Valerious
Rebecca MacIntyre
Rebecca Weber
Rina Miller
Robert Kimball
Robert Krauß
Robert Maddox
Robin Whitley
Roderic L Perkins
Rodney Bernaldo
Rohit Bery
Rowena Norman
Roxy Diederich
Ruth Bardenstein
Sam Oades
Sandy Carter
Sanjaya Kumar

Sara Graf
Sarah Caldwell
Sarah Goudelock
Scott Horowitz
Scott Pease
Scott Wiener
Seth Weber
Severa Maerker
Shabd Khalsa
Shannon Estabrook
Sharon McClanahan
Sharon Wood
Sharron Sarchet
Shawn P Noel
Shin Uchino
Sofia Fenichell
Stacey Milliken
Stefanie Maria Czapla
Stella Karageorgi
Stephanie R Metler
Stephen Gabbott
Stephen L Ranzini
Stephen R Burling
Steve Cook
Steve Rubin
Stuart Chalin
Su Mei Mei
Susan Berger
Susan L Mueller
Susan Z Eisinger
Suzanne Tainter
Tammie Nahra
Teo Hui Han
Teresa C Jong
Terri Wilkerson
Theresa L Walunas
Theresa M Hoffman
Theresa Marsik
Thomas B Sherrill
Thomas Beller
Thomas D Stauffer
Thomas Kern
Thomas Liljerum
Thomas Pfennig
Thomas Wolfson
Charles & Tina Avsharian
Tina Sayer
Tish Pomykal
Tom Phillips
Tracie Price
Tyrus J Peace
Ute Hattendorf
Valarie Miner
Victoria Fahlgren
Victoria Newton
Vidal-Naquet
Vipin Gupta
William C Pearson
William Kryska
Willis Lee
Wilson K Choi
Yessenia Martinez
Yun Zou
Yvonne van Valen

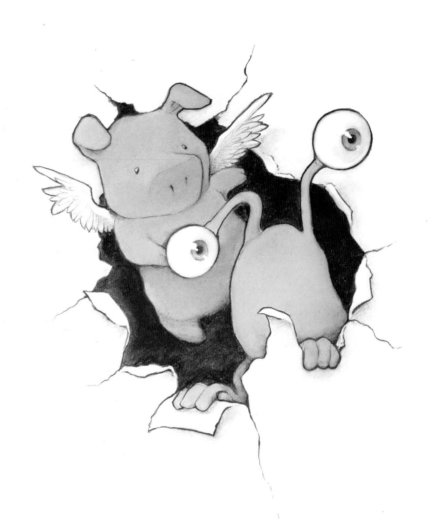